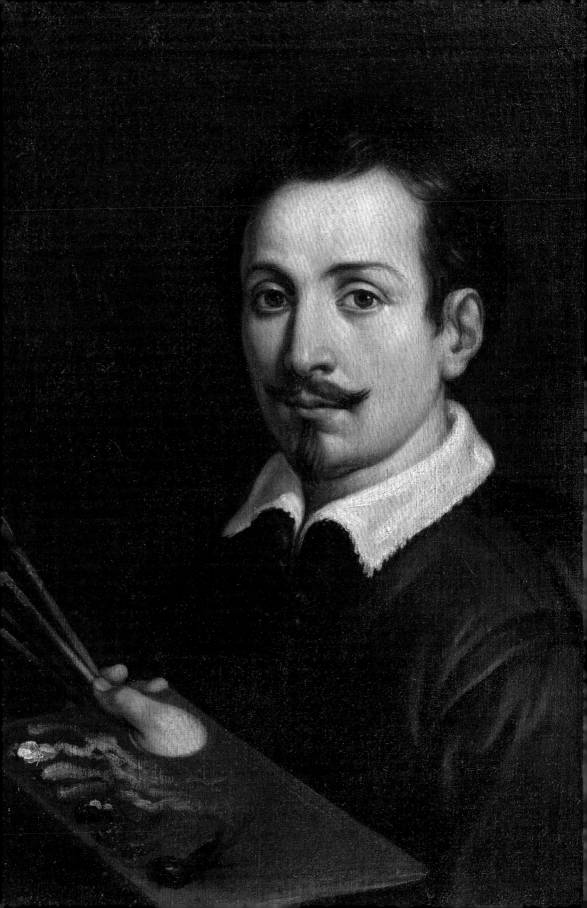

GUIDO RENI IN ROME

A Guide

texts by
ROMEO PIO CRISTOFORI and LARA SCANU
foreword by
FRANCESCA CAPPELLETTI
introduction by
RAFFAELLA MORSELLI

Marsilio Arte

Acknowledgements
Alessandra Avagliano
Fabio Bevilacqua
Lucia Calzona
Francesca Cappelletti
Anastasia Diaz della Vittoria Pallavicini
Sergio Guarino
Geraldine Leardi
Stefano L'Occaso
Marialucia Menegatti
Marina Minozzi
Raffaella Morselli
Lorenzo Pericolo
Thomas Clement Salomon
Maria Giovanna Sarti
Umberto Scopa
Cecilia Vicentini

The general layout of the text and its subdivision is the
work of the authors.
In particular, Lara Scanu drafted the texts on the
following pages
16–18, 22, 28, 30, 33, 36, 38, 49, 56, 60–61, 68, 74, 76–
78, 86, 88, 90, 96, 100, 104, 106, 110, 112, 120, 122–123,
and Romeo Pio Cristofori wrote the texts on pages:
20, 24, 26–27, 34, 40–42, 58, 62, 64, 67, 70, 72, 81–84,
92, 94–95, 98, 102–103, 108, 114, 116, 118, 124, 128.
The following pages are the result of joint work
11–13, 44–45, 50, 52, 133–143

Opening hours are subject to change. Visits are
not allowed during church services. An admissions
ticket may be required. For up-to-date information on
entrance requirements please check the website.

Graphic design
Studio grafico Bosi
Layout
Laura Ribul
Translations
Sylvia Adrian Notini
Copy Editing
Karen Tomatis

www.marsilioeditori.it

Cover: Guido Reni, *The Virgin Mary Sewing in the
Temple*, detail, 1609–1611, Annunziata Chapel,
Quirinal Palace.

On p. 2: Guido Reni, *Self-Portrait*, 1602–1603, London,
private collection.

On p. 8: Guido Reni, *Portrait of Cardinal Roberto
Ubaldini*, detail, 1627, Los Angeles, LACMA.

Discovering Guido, in Rome

FRANCESCA CAPPELLETTI

The idea for this Roman tour in search of the works of Guido Reni stems from the hope that the temporary exhibitions being held in museums will be reflected on the city, thus enhancing people's knowledge of it.

The exhibition, *Guido Reni in Rome. Nature and Devotion* (Galleria Borghese, March 1 – May 22, 2022), focuses on the years the great Bolognese artist spent in the papal city, between 1601 and 1614. Throughout his life Guido had other opportunities to return to the city and to send some of his works there, but his stay in Rome in the early part of the century is the period that allows us to best interpret one of his most particular masterpieces: the *Landscape with a Country Dance*. Previously in the collection of Scipione Borghese (1577–1633), lost in the late nineteenth century, and reacquired by the Galleria Borghese in 2020, this painting, on which studies are still being conducted, combines various aspects of the artist's Roman sojourn and his ability to respond to the environment and the lifestyle of the great city.

Here, then, is the city: in the itineraries outlined by Romeo Pio Cristofori and Lara Scanu, with insightful analyses, Guido Reni's Rome unfurls along a route that emerges from the Galleria Borghese and meanders between churches, museums, and palazzi. With our guide in hand, not only do we discover the places where Guido spent that eventful period of his life, but we can also appreciate his entire activity, admiring his latest canvases made for the Musei Capitolini and stepping into the Gallerie Nazionali of Palazzo Barberini and the Galleria of Palazzo Spada, where we find works that require a different kind of narrative, almost a hiatus in the artist's Roman adventure.

Following our guide, we are invited each time to pause and look at paintings like the so-called "Beatrice Cenci" in Palazzo Barberini or the *Abduction of Helen* in Palazzo Spada: regardless of problems related to attribution, they are both particularly significant to our understanding of some of the phases in the artist's career, or the dynamics of the romantic creation of a myth around him. As we take a break we can reflect on the fame of the portrait of Beatrice Cenci attributed to Guido, which probably does not represent Beatrice, and may not even have been made by him, or on the story of the *Abduction of Helen*, a work that made him even more famous and in demand from the European courts, and one that Cardinal Spada (1594–1661) managed to get at least one copy of from the master's workshop.

Along our tour the stories become interwoven, guiding us inside some extraordinary places, from the Accademia di San Luca to the church of the Trinità dei Pellegrini: on the altar there we see the apotheosis of a subject that Guido had been working on from his early years, and that here, in the mid-1620s, reached the height of perfection. The grand and rational conception of the composition, the explosive elegance of the colors, and

the naturalistic elements are harmonized here in a triumphant language that was unequalled in contemporary Baroque painting. Just across the Tiber our journey ends where it all began: the work site of Santa Cecilia in Trastevere. This is where Guido, as soon as he arrived in Rome, worked for Paolo Emilio Sfondrati (1560–1618), in an atmosphere that was filled with the frenetic search for and recovery of Early Christian relics. Again we learn about the history of the Basilica, understand the early phases of the building's construction, and the way in which the Bolognese artist's works were added to this and to other contexts. Guido Reni's Rome, from the public museums to the medieval churches, narrated through the complexity of these sites and the story of how they were viewed, is our chance to understand the times and the places of this artist.

Introduction

RAFFAELLA MORSELLI

From the early seventeenth century, in the periegetic literature on Rome, Guido Reni became a name that could not be overlooked. His many works in the churches and the palazzi changed the course of the way the eternal city was seen. Pilgrims and travelers need to know, both for reasons of religious faith and as concerns the city's decorative work, which points of interest simply cannot be missed: the ancient and modern churches, the basilicas, the palaces of the popes, the gardens of wonder, the ancient remains that are a measure of the greatness of the Republic and imperial city, the residences of the cardinals and the ambassadors. In the 1638 guidebook *Ritratto di Roma Moderna* compiled by Pompilio Totti (1591?–1639)—while Guido was still active in Bologna—and dedicated to Cardinal Antonio Barberini (1607–1671), the author pointed out many work sites and places where one could encounter the Bolognese artists who were embellishing the city. In alphabetical order, and not in order of relevance, we find Francesco Albani (1578–1660), a companion of Guido when he arrived in Rome, who initally collaborated with him, but eventually withdrew for reasons of rivalry; Annibale Carracci (1560–1609), of course, although Reni was never under his wing in Rome; Domenichino (1581–1641), another artist with whom Reni had arrived in Rome, and who would settle there permanently; there is a fleeting mention of Guercino (1591–1666), who remained in Rome for too short a time, between 1621 and 1623, to be given an important part in the guidebook; Lavinia Fontana (1552–1614), a woman of "the rarest gifts," the daughter of Prospero (1512–1597), who was one of the masters the young Reni looked up to; and lastly, there is Reni himself, the "Divin Guido", whose nine mentions are matched only by those of Domenichino. Totti offers several itineraries along the *rioni* of the eternal city, indicating two of Reni's works in the palazzi and seven inside churches: the "very rare paintings" of Palazzo Bentivoglio, now Pallavicini Rospigliosi correspond to the fresco with the sublime *Aurora*, and the adjacent chapel in the papal palace of Montecavallo dedicated to the Virgin Mary; for the churches he obviously lists the painter's work in the Cappella Paolina in Santa Maria Maggiore, devoted "to the famous image of Mary"; the altarpiece for the church of the Santissima Trinità and the Ospedale dei Pellegrini (in loco), for which he indicates, the only time, Guido's provenance; the altarpiece for the chapel to the left of the church of San Paolo alle Tre Fontane (Vatican Museums), commissioned by Pietro Aldobrandini (1571–1621), commendatory of the abbey, which Totti describes as "a wonderful painting by the great Guido Reni"; his *Saint Michael the Archangel* for the Capuchins (in loco), compared with the works of other "very famous painters"; the fresco with the story of Saint Andrew for the Oratory of the saint in the church of San Gregorio Magno al Celio, to which

he adds the *Martyrdom of Saint Cecilia* (which is, instead, in Santa Cecilia in Trastevere still today), and, lastly, the *Vision of Saint Philip Neri* in Santa Maria in Vallicella, for which Guido created the official image of the saint that would forever be successful.

It is clear from the start, beyond the individual mentions, that the painter is included in the list of his peers of the time: Baglione (1573–1643), Il Cavalier d'Arpino (1568–1640), Cigoli (1559–1613), Pompeo Targone (1575–1630), that is, the finest artists the city had to offer from the days of Reni's arrival there. In the following decades, by the time Reni had returned to Bologna permanently but continued to execute public and private commissions for Rome, he was compared to Sacchi (1559–1661), Cortona (1597–1669), and Lanfranco (1582–1647). There has never been any doubt about Guido Reni's great talent and fame.

Almost four centuries later, this guidebook updates that of Pompilio Totti, adding everything that over this period of time has been transferred from private collections to contemporary museums, and that has emerged and is visible in the collections of the aristocratic families that collected the artist's works during his professional life, or subsequently, either as collectors or as heirs. Wandering around Rome in search of Guido Reni today, just like in the seventeenth century, means letting oneself be transported by the beauty and the narrative that are both interwoven with the stories of saints, martyrs, legends, and the people he portrayed.

Notes on the Itinerary

When Guido Reni left Rome in 1614 he was one of the most famous artists of the day, having already received from faraway Paris his first commissions from the royal French family. Vied over by the most powerful Roman families, his works could be viewed in the major aristocratic galleries, in the rooms of popes, in the basilicas and in the churches, as well as in the halls where the confraternities and city congregations assembled. Having arrived in the capital in the early seventeenth century, the Bolognese painter established, commission after commission, a special and exclusive relationship with the papal city that still today holds and safeguards many of his works. It may seem a paradox, but to really get to know one of the greatest painters of the Emilian school, you must visit Rome, the city that, after Bologna, his birthplace, contributed significantly to his artistic training and success.
For all the above reasons, the aim of this guidebook is to serve as a companion on the journey to discover—or rediscover—works by Guido Reni currently in Rome that were either executed during his stay in the capital, or made after he returned to his native city. The guidebook will provide further information on a selection of paintings by the artist, as well as indications required for an overview of the city and the places where the works are kept. Several prints made while the painter was alive, or soon after his death are included here as well, so that readers will be able to identify the place they are visiting and also see it the same way that Reni was able to experience and observe it with his own eyes.
The works were chosen based on their presence in the documents related to the individual collections where they are held, and on their authenticity, confirmed on multiple occasions by art-historical studies. For this reason appendices have been included at the end of the tour to help the reader-visitor learn even more about the painter either during or after the itinerary. Starting from the Galleria Borghese, the path unwinds through the streets of Rome all the way to the Vatican. Both of these sites represent a golden period in Reni's production, which took place during the papacy of Pope Paul Borghese (1605–1621). It was a time when the artist was working intensely, achieving results that led him from being a simple Bolognese painter and pupil of the Carracci, to his consecration as the "Divin Guido", previously equalled only by Raphael.

The Seicento. (Re)Discovering Rome between the Sacred and the Profane

Strolling down the alleyways in Rome in the year 1600, at the dawning of the Grand Jubilee that also marked the start of a new century filled with many new things, the young Guido Reni would have had a chance to come across the various work sites where important urban projects were being completed. These had begun around twenty-five years earlier under Pope Sixtus V Peretti (1521–1590) during the previous Holy Years (1585–1590). The works under way did not just involve pre-existing buildings whose decorations needed to be completed or restored, but also new *fabbriche*, or new pictorial campaigns begun on the occasion of the rediscovery or relocating of an important relic that could be offered to believers as a fundamental stop on their jubilee pilgrimage. This circumstance must have led Reni, who was a little over twenty years of age, to the papal city, summoned by Cardinal Paolo Emilio Sfondrati (1560–1618). Sfrondati, like the other cardinals who were titulars of the Roman Basilicas, was involved in a movement to valorize Early Christianity anew, once more bringing back to the center of attention the worship of the saints and the veneration of the testimonies of the first martyrs, whose devotional importance had been cast into doubt by the Protestant movements in Northern Europe.

To guide the believers toward the Catholic message as directly as possible, the Church established specific canons for the creation of artworks that had to contain simple, effective images that were easy to interpret, and capable of conveying to the less-educated worshippers the fundamental principles of Christian morality and doctrine through the gestures, expressions, and great and sacred stories staged in the paintings themselves. The treatises that were being written at the time talked about *mozione degli affetti*, in other words, the movement of the emotions aroused by a work of art, thereby favoring the execution of pious and charitable deeds.

The union of these two factors—the creation of great works and the need for a new art—stimulated that generation of artists, who, from Caravaggio (1571–1610) to Reni, chose as their own display case a city that was undergoing sweeping change, the throbbing heart of seventeenth-century Europe, and the capital of Christianity. Between 1605 and 1621, a crucial role was played by Paolo V Borghese (1552–1621) and his cardinal nephew Scipione (1577–1633): thanks to their commissions they were able to take advantage of the jubilee initiatives that had begun with Clement VIII Aldobrandini (1533–1605), thus creating fertile ground for the birth of the great season of the Baroque.

Guido Reni: A Short Biography

Born near Bologna in 1575, at first Guido Reni joined the workshop of the Flemish painter Denis Calvaert (1585–1594), but he then moved over to that of the Accademia dei Carracci following in the footsteps of Annibale (1560–1609) and Ludovico (1555–1619). In 1601 he was summoned to Rome by the cardinal and titular of the Basilica Santa Cecilia in Trastevere Paolo Emilio Sfondrati (1560–1618, see pp. 112–113). Guido Reni remained in the eternal city until 1614 except for a few short interruptions, for example when he was called to decorate the cloister of the church of San Michele in Bosco in Bologna (1603–1604), after which he twice returned to Rome, in 1621 and in 1627. For the painter the capital city was fertile ground where he could practice new artistic methods, such as the works he produced inspired by the experiments that were being conducted by Caravaggio (1571–1610), combined with his particular taste for balance and Renaissance classicism. In 1608 Reni began working for the Borghese family in Rome, with the help of one of the most important painters on the Roman art scene, Giuseppe Cesari, known as Cavalier d'Arpino (1568–1640). At the same time, he continued to fulfill his Bolognese commissions, one of which was the renowned *Massacre of the Innocents,* which he made in 1610 and can now be viewed at the Pinacoteca Nazionale in Bologna. In Italy he soon became the most important artist of his time, using a new manner to interpret the Carracci's studies on the figures in the works of Raphael (1483–1520) and Correggio (1489–1534) and on the colors of sixteenth-century Venetian paintings, but always with a keen eye on what was new and present in the city of the popes thanks to the presence of artists like Pieter Paul Rubens (1577–1640). With the mediation of Cardinal Bernardino Spada (1594–1661, see pp. 78–79), then-papal legate in Bologna, Reni made the *Abduction of Helen* for Queen Marie de' Medici of France (1575–1642) (see pp. 80–81). In 1631 he executed what may be seen as one of his most important mature works, the *Pala della Peste*, now at the Pinacoteca Nazionale in Bologna. The artist continued to work in his native city until 1642, the year of his death, a fact that is confirmed by the presence on that date of various unfinished works in his workshop.

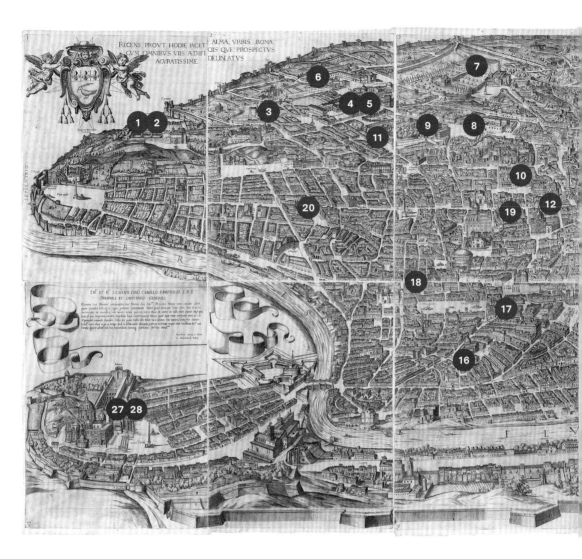

Itinerary

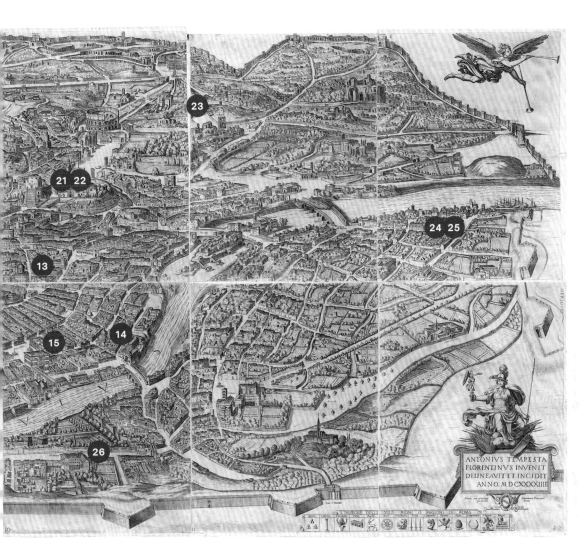

Antonio Tempesta,
View of Rome, 1593, New York,
The Metropolitan Museum of Art

Galleria Borghese

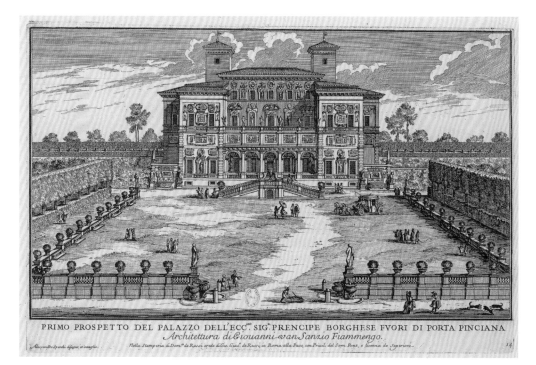

PRIMO PROSPETTO DEL PALAZZO DELL'ECC.ᵐᵒ SIG. PRENCIPE BORGHESE FVORI DI PORTA PINCIANA
Architettura di Giouanni-ovan Sanzio Fiammengo.

Giovanni Battista Falda, *View of the Main Facade of the Casino Borghese outside of Porta Pinciana*, 1665–1739, from *Il Nuovo teatro delle fabriche et edificii in prospettiva di Roman moderna*, Bibliothèque nationale de France.

The museum, truly an architectural gem and a trove of masterpieces, is located in the so-called Casino di Porta Pinciana, at one time the residence of Cardinal Scipione Borghese, (1577–1633) designed by Flaminio Ponzio (1560–1613), and completed by Jan van Santen, a Flemish artist known by his Italianized name Giovanni Vasanzio (1550–1621), in 1617. In 1608 the prelate and nephew of Pope Paul V Borghese (1550–1621) purchased the statues of Palazzo Ceoli—now Sacchetti—and in 1609 the ones that had belonged to the sculptor Giovan Battista Della Porta (1542–1597). In 1770 the villa was almost completely remodeled by Antonio Asprucci (1723–1808) at the behest of Marcantonio IV Borghese (1730–1800): the most spectacular example of the eighteenth-century remodeling that was carried out is the entrance hall, named after the painter Mariano Rossi (1731–1807) who decorated the ceiling with an image of *Romulus Welcomed to the Olympus by Jupiter to Appease the Victory of Furius Camillus against Brennus King of the Gauls* (1775–1779). The architect succeeded in including the sculpture of *Marcus Curtius Throwing Himself into the Chasm*, which was initially located on the outer facade. The work consisted of a horse made in the second century CE that

Scipione had asked **Pietro Bernini** (1562–1629) to restore in 1618, adding a knight and thus achieving its current form. The only two rooms that still have their original frescoes are the *Cappella*, where the *Assunta* (1617–1618) made by Claude Deruet (1588–1660) can be seen, and the loggia, whose ceiling is decorated with the monumental *Council of Gods* (1624–1625) by the Parma-born painter **Giovanni Lanfranco** (1582–1647). This room now hosts the main collection of the Galleria Borghese picture gallery.

Regardless of the fact that the current collection is substantially different from what it was in Scipione's day, most of the masterpieces that Cardinal Borghese was fond of are still present. The Galleria is the only institution to have some six paintings by **Caravaggio** (1571–1610), examples of each of the phases in the Lombard painter's career, along with works by the major seventeenth-century artists: from the sculptural groups and portraits by **Gian Lorenzo Bernini** (1598–1680), represented here as both a painter and a sculptor, to the canvases of Domenico Zampieri called **Domenichino** (1581–1641), **Pieter Paul Rubens** (1577–1640), Giovan Francesco Barbieri called **Guercino** (1591–1666), **Annibale Carracci** (1560–1609), **Lavinia Fontana** (1552–1614), and **Guido Reni**. To this painter are referred the *Moses* and the *Landscape with a Country Dance*, a painting originally belonging to the cardinal's collection and recently acquired. The visit to the museum is not limited to a viewing of these works: it also includes precious antique marbles, as well as paintings by some of the Renaissance masters: the *Deposition* (1507) by **Raphael** (1483–1520), as well as canvases by **Titian** (1488/1490–1576), Paolo Caliari called **Veronese** (1528–1588), and Antonio Allegri called **Correggio** (1489–1534), sculptures by **Luigi Valadier** (1726–1785), and *Paolina Borghese as Venus Victorious* (1804–1808) by **Antonio Canova** (1757–1822), among others.

GALLERIA BORGHESE
Piazzale Scipione Borghese, 5 – 00197, Rome
Tuesday–Sunday (closed Monday)
open 9am–7pm (last entry before closing 5:45pm)
advance booking required: +39 06 32810
galleriaborghese.beniculturali.it

Landscape with a Country Dance

Circa 1605–1606
Oil on canvas, 81 x 99 cm

Acquired in 2020 by the Galleria Borghese after its appearance on the antiques market in 2008, this painting, is a unique example of Guido Reni's skill at painting landscapes.
In the foreground, immersed in a sloping hillside landscape and shrouded in a light blue air that would seem to transform the slopes into large patches of cerulean mist, just below a small hamlet characterized by houses and a parish church similar to the ones present in the Tuscan-Emilian Apennines, is a gathering of peasants sitting in a circle holding musical instruments. Near the improvised concert, not far from a stream with a small waterfall that is just hinted at, over which there is a bridge crossed by a woman holding the hand of a child followed by a dog, a young peasant invites a lady to dance. All the figures present, from the hunters to the women, from the musicians to the children, are dressed in their Sunday best, wearing lively, bright colored clothes. The lush vegetation is like a stage curtain, with a clearing for the dancers and their audience.
In this painting, Guido Reni shows his patrons that he is well aware of his painting skills, starting from the description of the tiniest details in the garments, for example, in the white collars worn by the ladies, the musical instruments, the village, especially the clothes hanging in front of the house at the upper left, the vegetation, the presence of swans along the small river to the right, and the meticulously painted small birds amidst the leaves. Perhaps this is why Guido chose to include at the top right some life-sized flies, almost as if he wanted to tempt the viewer to swat them away. This recalls the anecdotes told by Philostratus and Pliny the Elder in which the idea was to prove a painter's great skill at reproducing reality.

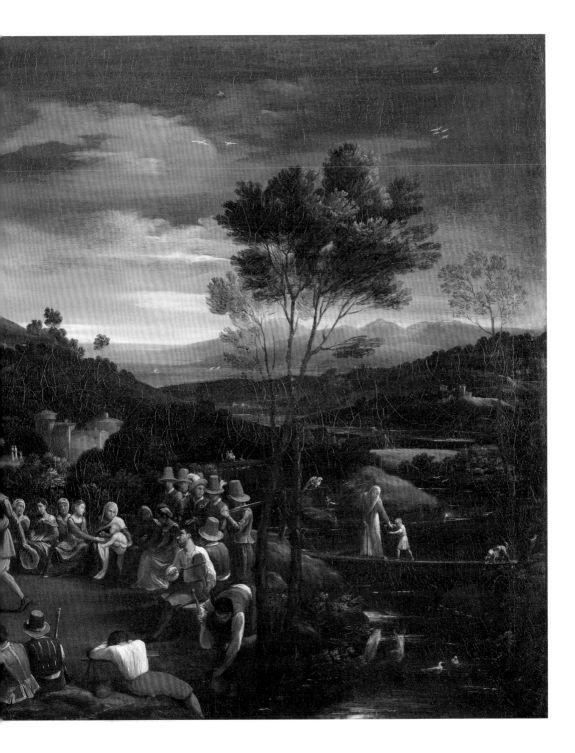

Moses Breaking the Tablets of the Law

1624–1625
Oil on canvas, 173 x 134 cm

Standing before a dark and stormy sky an elderly Moses is about to throw down the tablets of the law that he has just received from God on Mount Sinai. In the distance to the right the viewer glimpses the people of Israel who, thinking that the prophet would never return, had asked Moses' brother, Aaron, to create a golden calf for them to worship. The blasphemous gesture of the Israelites unleashes the rage of the wise Hebrew leader: upon arriving in the camp he destroys the sacred tablets and turns his wrath against the sinful idol. This painting of a relatively uncommon Old Testament theme was probably made by Guido Reni in the first half of the 1620s, and was acquired by Cardinal Scipione Borghese (1577–1633) directly from the artist. Very little is known about its collecting history. The erudite Francesco Scannelli (1616–1663), in the work *Microcosmo della pittura* (a history of Italian painting from the fifteenth century published in 1657), describes the canvas, attributing it without hesitation to the Bolognese master and placing it already in the Palazzo Borghese collection, where it was again listed in the inventory of 1693. However, Reni's name was soon forgotten and mistakenly replaced by that of Giovan Francesco Barbieri, called Guercino (1591–1666). Reni's name was once again mentioned in the nineteenth-century inventories of the Borghese collection, and was corroborated when the painting was acquired by the state (1902). The attribution is confirmed by both the historical nature of the aforementioned records, and the monumentality of the figure of Moses, whose soft red mantle bestows an air of solemnity and magnificence typical of other Renian works that are chronologically close. The accurate description of the face, scowling with rage and distorted by the vehemence of his action, make the composition a strongly dramatic one, and turn the canvas into an interesting example of the representation of history, filled with pathos and drama, that characterized Roman painting in that century.

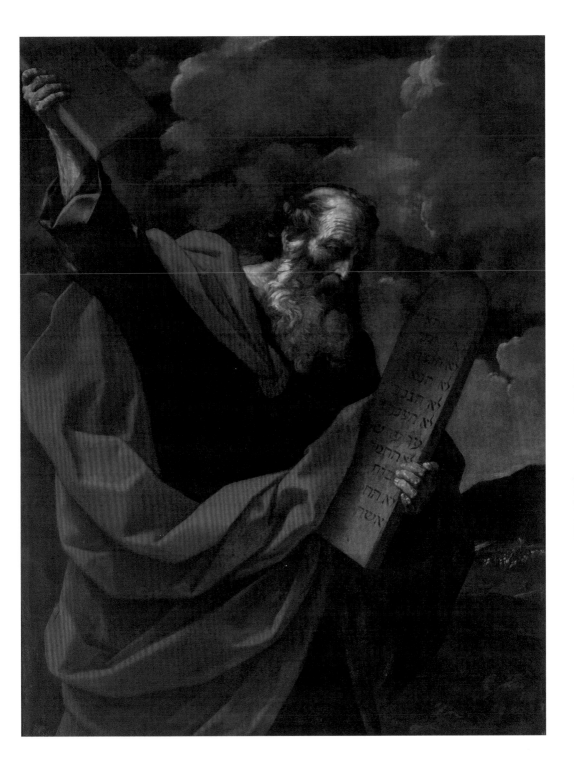

Church of Santa Maria della Concezione dei Cappuccini

Located almost at the end of Via Veneto, close to today's Piazza Barberini, the church was built between 1626 and 1630 by the architect Antonio Felice Casoni (1559–1634) thanks to funding from Cardinal Antonio Barberini (1569–1646). The prelate wanted to be buried in this church in a very simple sepulchre, and indeed the only thing visible on his tomb is the rather meaningful inscription for this site: HIC IACET PULVIS, CINIS ET NIHIL (Here lie only dust and ashes). The church is above all known for the adjacent cemetery of the Capuchins, which occupies five rooms completely decorated with the skeletal remains of around four thousand brethren buried between 1528 and 1870 in the old burial ground of the church of Santa Croce e San Bonaventura dei Lucchesi near the Quirinal. Although the decision they made may seem sinister, the Capuchins did so with the specific aim of underscoring for the faithful that the body is no more than a container for the soul: once it has been emptied, it can have another purpose. Initially positioned in a square in the open countryside and featuring a bell tower, which was then torn down after the Unification of Italy in order to build Via Veneto, inside it are some of the major masterpieces of seventeenth-century Roman painting. In the same chapel with Guido Reni's *Saint Michael the Archangel* is *The Mocking of Christ* by Gerrit von Honthorst, known in Italy as **Gherardo delle Notti** (1592–1656). The other chapels house paintings by Domenico Zampieri, called **Domenichino** (1581–1641), **Giovanni Lanfranco** (1582–1647), **Andrea Sacchi** (1599–1661), and Pietro Berrettini, called **Pietro da Cortona** (1597–1669). The convent also hosts the *Saint Francis Praying* that was originally attributed to **Caravaggio** (1571–1610).

Giuseppe Vasi, *View of the Convent and Church of the Capuchin Friars*,
1747–1801, Istituto Centrale per la Grafica di Roma.

CHURCH OF SANTA MARIA DELLA CONCEZIONE DEI CAPPUCCINI
Via Vittorio Veneto, 27 – 00187, Rome
open 7am–1pm; 3pm–6pm
Sunday and holidays
open 9:30am–noon; 3:30pm–6pm
the *Museum and Crypt of the Capuchin Monks* is also open to visitors
Monday–Sunday
open 10am–7pm (last entry before closing 6:30pm)
www.cappucciniviaveneto.it

Saint Michael the Archangel

1635
Oil on silk, 173 x 134 cm

In a letter Guido Reni sent to Monsignor Cassani, master of the house of Urban VIII (1568–1644), concerning the monumental canvas for the church of the Capuchins in Rome, he wrote:

"Vorrei haver avuto pennello Angelico, o forme di Paradiso, per formare l'Arcangelo, e vederlo in Cielo, ma io non ho potuto salir tant'alto, ed invano l'ho cercate in terra. Sicché ho guardato in quella forma, che nell'idea mi sono stabilita [...]" (I would like to have had an Angelic paintbrush, or the forms of Paradise, to be able to shape the Archangel, and to see him in the Heavens, but I was not able to climb so far up, and in vain I searched for them on Earth. Thus I saw in that form, what I had established in the idea itself.)

The Bolognese painter strongly defended an ideal representation, far-removed from the Caravaggesque realism he had experimented with in his early Roman years, thus claiming his embrace of those aesthetic theories proclaimed a few years later by Giovanni Pietro Bellori (1613–1696), among the most important seventeenth-century biographers. In 1672, in *Lives of the Painters* the Roman theorist wrote that Reni boasted of "not painting the beauty that was offered to his eyes, but the beauty that he saw in the Idea [...]." And, indeed, the monumental Archangel standing out against the dark background of the silk canvas, in addition to referring to the same subject painted by Raphael (1483–1520) now in the Louvre, is an extraordinary synthesis of balanced and well-proportioned classicism. Nothing is excessive, nothing is extreme, everything contributes to the creation of a controlled and calculated composition where even the pastel colors and the light devoid of strong contrasts contribute to the

creation of an image that still today has not lost its extraordinary devotional strength. The canvas was made by the artist in Bologna and sent to Rome by 1635, seeing that the following year an engraving of it was made by Giovanni Giacomo De Rossi (1627–1691). The work was commissioned by the cardinal of Sant'Onofrio and brother of Pope Urban VIII, Antonio Barberini (1569–1646), who was summoned back to Rome in 1623, after he had entered a Capuchin monastery in Florence in 1591. Ordered to leave Florence, Antonio moved to the papal city, where he accepted a cardinalship. He turned his attention to the Roman church of his own order, commissioning the general refurbishment of the church devoted to Saint Mary of the Conception. Clashing with the other members of the community, who interpreted the austerity and poverty of the church as the practical side of the poverty that their vows demanded of them, the newly-appointed cardinal turned to numerous artists to renew the altars. This extraordinary move to modernize the site brought the Bolognese painter back to Rome, albeit without an invitation or a place to stay in the city. Nonetheless, this would turn him into one of the major interpreters of the century. *Saint Michael the Archangel* became the emblematic work of the "Divin Guido", the highest possible threshold of painting so ideal it would earn the complete admiration of the eighteenth-century French cultural milieu, and serve as the standard-bearer of classicism. An ideal construction that did not succeed, in any case, in stopping a popular interpretation— albeit one that was denied by Reni himself— which saw in the face of the devil on the ground that of then Cardinal Giovanni Battista Pamphilj, the future Pope Innocent X (1574–1655), who was notoriously on bad terms with the Barberini.

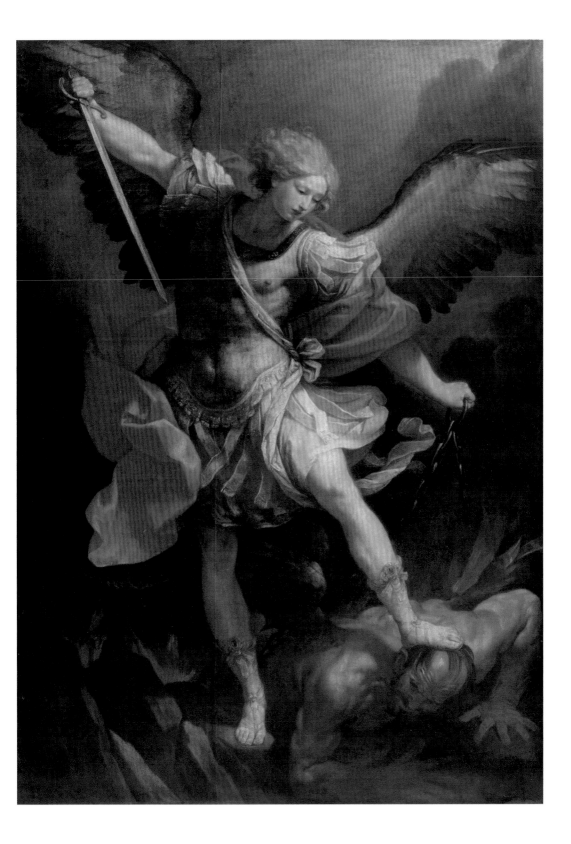

Galleria Nazionale d'Arte Antica
Palazzo Barberini

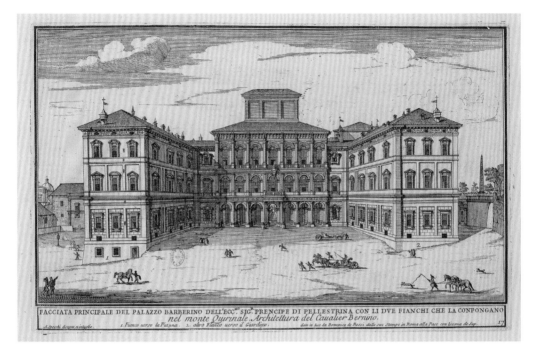

Giovanni Battista Falda, *View of the Principal Facade of Palazzo Barberini*,
1665–1739, from *Il Nuovo teatro delle fabriche et edificii
in prospettiva di Roma moderna*, Bibliothèque nationale de France.

This great architectural complex, now the seat of the Galleria Nazionale d'Arte
Antica, is the high point of the extraordinary social, economic, and cultural
ascent of the Barberini family in the first two decades of the seventeenth
century. The ascent to the papacy of Cardinal Maffeo Baberini (1568–1644),
on August 5, 1623, was powerful proof of the Tuscan family's need for a
prestigious dwelling, so that it could proudly take its place alongside the
historical families of the Roman aristocracy. The Barberini family thus acquired
from the Sforza family an ancient building that had already been sold in 1549
by Cardinal Pio da Carpi (1500–1564) to the Cesi family, after which it had been
purchased by the Della Rovere. Taking advantage of a moment of economic
hardship for the Sforza, who had become the owners of the original building
in 1581, the Barberini managed to acquire the complex as well as an area that
could host a large building halfway between a bucolic suburban villa and a
sumptuous city palazzo. By englobing the pre-existing structure, the architect
Carlo Maderno (1556–1629), with the collaboration of the younger Francesco
Borromini (1599–1667), created, from 1625, an H-shaped building with a vast
garden at the rear and a large entrance loggia. After Maderno's death in 1629,
Gian Lorenzo Bernini (1598–1680) took over the planning and management

of the construction site. Although he did not make significant changes to the original plan, he did add some new decorative and structural elements like the large staircase of honor featuring a square stairwell, or the monumental central salon that occupies two floors of the palazzo. The architectural work site ended in 1633, however, in 1632 it was accompanied by a decorative campaign for which **Pietro da Cortona** (1597–1669) made the fresco depicting the *Triumph of Divine Providence* in the great salon on the piano nobile, while **Andrea Sacchi** (1599–1661) and **Giovan Francesco Romanelli** (circa 1610–1662) were active in the smaller adjacent rooms. The sumptuous palazzo was completed in the early 1640s and was immediately chosen as the headquarters for the nobiliary art collections. Starting with Maffeo Barberini himself (who was later elected Pope Urban VIII), these collections had grown throughout the seventeenth and eighteenth centuries, differing in terms of value and genre in the family's many palazzi. The collection could be preserved thanks to the legal binding of the trust that was confirmed even in the wake of the advent of Savoy rule; however, it was irremediably destroyed in 1934 due to a new Royal Decree that allowed the family to sell its collections in exchange for a small group of properties to be donated to the State. The building was thus quickly emptied out of its prestigious guests and leased to private parties or to entities like the Circolo Ufficiali delle Forze Armate d'Italia, which remained there until 2006. The sale of the building to the State Property in 1949 made it possible for it to become the seat of the Galleria Nazionale d'Arte Antica, founded in 1895 and for many years the venue of outstanding and diverse collections (Corsini, Torlonia, Monte di Pietà, Barberini) as well as of specific and carefully selected acquisitions and gifts. The institute thus had rooms and spaces that were needed to contain an outstanding collection (1445 paintings and 2,067 art objects), including the *La Fornarina* by **Raphael** (1483–1520), the *Mystical Marriage of Saint Catherine* by **Lorenzo Lotto** (1480–1556/1557), *Venus and Adonis* by **Titian** (1488/1490–1576), *Judith Beheading Holofernes* by **Caravaggio** (1571–1610), and *Et in Arcadia Ego* by **Guercino** (1591–1666).

GALLERIA NAZIONALE D'ARTE ANTICA – PALAZZO BARBERINI
Via delle Quattro Fontane, 13 – 00184, Rome
Tuesday–Sunday (closed Monday)
open 9am–6pm (last entry before closing 5pm)
advance booking required during the weekend and for groups:
+39 06 32810
www.barberinicorsini.org

Sleeping Putto

Circa 1627
Fresco, 57 x 56 cm

Perfectly positioned according to the rules of perspective, before the viewer's eyes is a chubby baby asleep on ochre yellow drapery. The image of this newborn baby is particularly realistic in the way it sleeps peacefully and serenely, occupying the viewer's space in a natural and life-like way.

The *Sleeping Putto* was made using the fresco technique. According to an anecdote that the sculptor Gian Lorenzo Bernini (1589–1680), in Paris in 1665, told the French collector Paul Fréart de Chantelou (1609–1694) Guido Reni—to practice his skills at this complex technique he was supposed to use to complete the decorations for the Basilica of Santa Maria Maggiore (see pp. 40–42) and San Giovanni in Laterano—swiftly painted the child before the eyes of the admiring and awe-struck Cardinal Barberini (1597–1679).

The work has been in the Barberini collection since 1629, the year it joined the painting collection of Cardinal Francesco Barberini. The anecdote told by Bernini probably refers to a fresco that Reni intended to make in Saint Peter's around 1627, but that he never did. This allows us to date the execution of this work close to his commission to work for the Vatican Basilica.

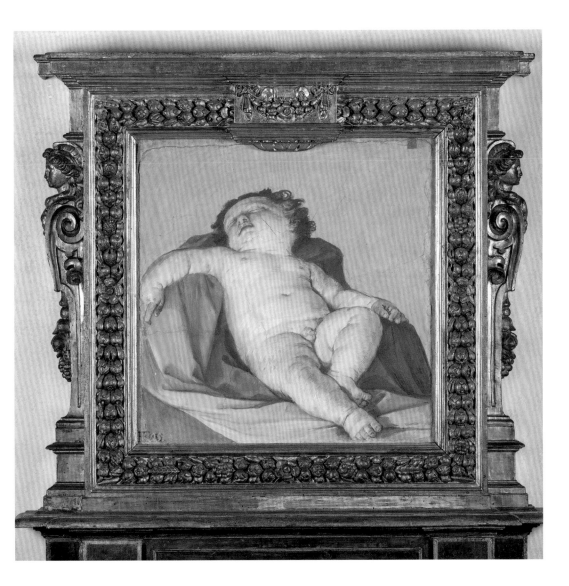

Penitent Magdalene

Circa 1630
Oil on canvas, 234 x 151 cm

Inside a large cave, two angels seemingly borne by a strong wind make their entrance from the outside, moving toward a woman sitting on a rock. Her skin is pale, her hair blonde, and she is looking mournfully into the void. Her left hand holds a skull atop a stone with a cross before it, while to the right is a small clump of roots, symbolizing fasting and abstinence. She is Mary Magdalene, one of the women closest to Jesus during his evangelical work. After repenting, she goes from being a sinner to a convert. In this painting she is depicted as a penitent, an image that was widespread between the late sixteenth and the early seventeenth centuries, especially after it was used by Cardinal Cesare Baronio (1538–1607) as a prototype of devotion toward the sacraments, in particular confession, which was as strongly supported during the Counter-Reformation by the Catholic Church as it was opposed by the Protestant Reform.

The painting was commissioned from Guido Reni by Cardinal Antonio Santacroce (1599–1641) around 1630, ending up, after the owner's death, in the collection of Cardinal Antonio Barberini.

The composition is characterized by the monumentally noble and spiritually mystic figure of the saint who is positioned diagonally thus completely filling the painting surface. While images of the saint often characterized her as being sensuous and lascivious, here she is represented as the very essence of faith, idealized in all her physical features under a generous robe and long hair. The artist chose an elegant, cold palette with lunar, silvery hues, expanding the background into a landscape accurately described by the earthy colors of the hillsides.

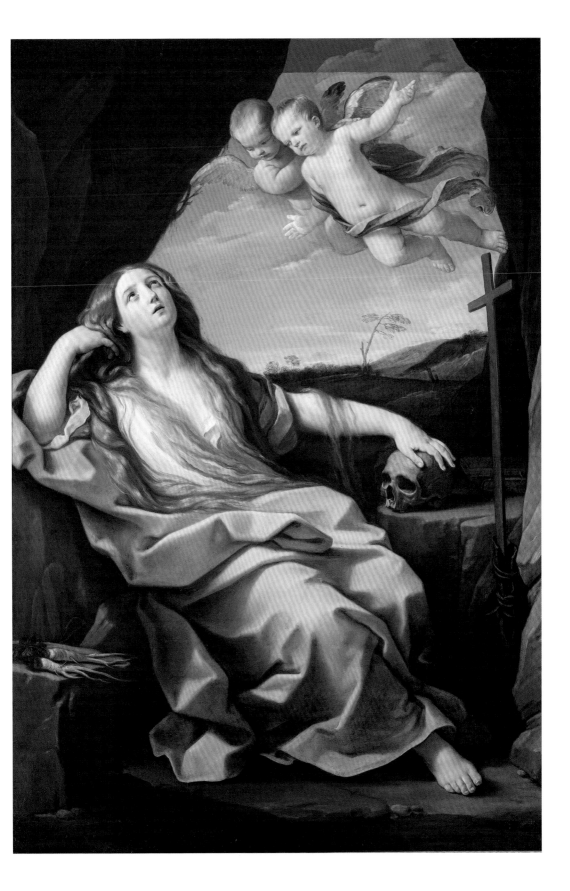

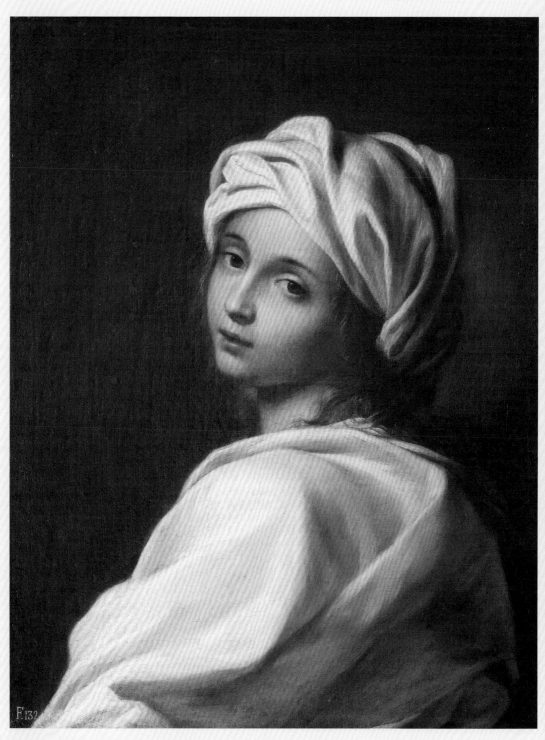

Guido Reni (attr.), *Portrait of a Young Woman
in a Turban (Beatrice Cenci)*, 1599–1600, Rome,
Galleria nazionale d'Arte Antica – Palazzo Barberini.

BEATRICE CENCI AND GUIDO RENI:
A LEGEND MADE OF STORIES AND IMAGES

Perhaps a Sibyl, perhaps a woman with a prophetic gift from the pagan world, or perhaps simply an unidentified historical figure. This portrait of a woman wearing a white turban—although the scholars no longer agree on attributing it to Guido Reni, instead favoring his fellow Bolognese Ginevra Cantofoli (1618–1672)—prolongs the mystery as to the identity of the young woman portrayed. According to the tradition initiated by the English poet Percy Bysshe Shelley (1792–1822), the face we see in the small canvas in Palazzo Barberini is that of Beatrice Cenci (1577–1599), a Roman noblewoman who was beheaded on September 11, 1599 in Castel Sant'Angelo, along with her stepmother Lucrezia and her brother Giacomo, for having murdered her father Francesco, a violent, abusive man.

Beatrice is portrayed at the very instant when she turns around, as if someone had called out her name, a somewhat surprised look in her eyes. The young woman seems to be directing her gaze toward the viewer. She is wearing a simple tunic, which fills the foreground with a complex game of drapery, and a sort of turban, which is also white. The portrait was associated with neither Cenci nor Reni until the eighteenth century. However, notwithstanding the lack of documents attesting to previous identifications or attributions, it is easy to imagine that the pair of names had previously made the rounds, and that in the eighteenth century they were already well on their way to becoming a legend. The events of the Cenci family and in particular those of the "character" of Beatrice were subject to a process of romantic idealization that nearly turned them into myth or legend. From the nineteenth century onwards, the events in the family's life inspired short stories, theatrical works, and novels written by Vincenzo Pieracci [*Beatrice Cenci*, 1816], Shelley [*The Cenci*, 1819], Stendhal [in *Chroniques italiennes*, 1829] Agostino Ademollo [*Istoria di Beatrice de' Cenci*, 1839], Alexandre Dumas père [*Les Cenci*, 1840], Słowacki [*Beatryks Cenci*, 1909], and Artaud [*The Cenci*, 1972]. The young Beatrice soon became the ideal symbol of the ruthlessness of justice and, broadly speaking, of executions during the modern age.

This small portrait contributed to fueling the myth of both Beatrice and Guido Reni. Legend has it that the Bolognese painter went to the prison shortly before the young woman was taken away to the gallows. The anecdote contributed to the request for numerous copies of the painting for various private collections or to be placed on the antiques market. Furthermore, the famous pair and the noir setting made the episode one of the favorite subjects for the painters of Risorgimento Italy. The artists often chose to represent the very moment when the Bolognese painter, wearing sumptuous Renaissance attire, portrayed the Roman noblewoman while detained in her cell, depicting her exactly as she is in the small portrait in Palazzo Barberini.

Church of Santa Maria della Vittoria

Built around 1608 to replace a previous chapel of the Discalced Carmelites, originally dedicated to Saint Paul, the church was almost finished in 1620. To finance the construction of the temple, designed by the architect Carlo Maderno (1556–1629), is once again Cardinal Scipione Borghese (1577–1633), to whom the Carmelite friars gave the extraordinary statue of the *Hermaphrodite* (now in the Louvre) rediscovered in 1609 during the first works on the complex. The building changed its name in the wake of the unexpected victory of the Catholic troops against the Protestant ones in the Battle of White Mountain (just outside Prague) in the Thirty Years' War (1618–1648). The church was in fact chosen as the future residence of an image of Mary, who was attributed with the victory of the troops of Ferdinand II of Habsburg on November 8, 1620. This new dedication to the Virgin and the extraordinary success of the worship of the Bohemian work over the high altar (which was lost in a fire around 1833) further enriched the building. It was completed in 1626 with a solemn, slender facade, inspired by that of the nearby church of Santa Susanna, made by Giovanni Battista Soria (1581–1651). The interior with a single nave and three chapels per side was the result of one of the highest and most sumptuous decorative campaigns in Baroque Rome, and it hosts some major seventeenth-century masterpieces. What especially stands out is the altarpiece portraying the *Virgin and Child with Saint Francis* (circa 1630) in the second chapel on the right, one of the last Roman works made by **Domenichino** (1581–1641), along with the two frescoes decorating the walls of the same space, that is, the *Saint Paul Caught up to the Third Heaven* (1620) by **Gerard von Honthorst** in the choir behind the altar. In the third chapel to the left is the *Holy Trinity* (circa 1642) by **Guercino** (1591–1666) and the funeral monument of Cardinal Berlinghiero Gessi featuring the wonderful portrait of the deceased painted by Guido Reni around 1641. The church was a celebration of Baroque splendor and a magnet for major commissions, as demonstrated by the extraordinary sepulchral chapel of Cardinal Cornaro in the left transept which includes **Gian Lorenzo Bernini**'s (1598–1680) exceptional marble carving of the *Ecstasy of Saint Teresa* as members of the Cornaro family look on from theater-boxes on either side.

Giovanni Battista Falda, *View of the Facade of the Church of Santa Maria della Vittoria*, 1665–1739, from *Il Nuovo teatro delle fabriche et edificii in prospettiva di Roma moderna*, Paris, Bibliothèque nationale de France.

CHURCH OF SANTA MARIA DELLA VITTORIA
Via XX Settembre, 17 – 00187, Rome
every day
open 8:30–noon; 3:30–6pm

Portrait of Cardinal Berlinghiero Gessi

Circa 1641
Oil on wood, 95 x 75 cm

Inside the third chapel to the left, which is dominated by the altarpiece made by Guercino (1591–1666) around 1642, on the right wall is the funeral monument of Cardinal Berlinghiero Gessi (1564–1639), crowned by the portrait made by Guido Reni.
A leading figure in the Church who was born in Bologna, Berlinghiero Gessi was related to Pope Gregory XIII Boncompagni (1502–1585). Gessi's ecclesiastical career advanced quickly: nominated Bishop of Rimini in the Sistine Chapel in 1606 by Paul V Borghese (1550–1621), the following year he was appointed papal nuncio of Venice, a post he held until 1618. He was later elected governor of Rome, a role he covered discontinuously owing to illness until 1623. In 1624 he was involved in the negotiations for the Devolution to the State of the Duchy of Urbino, seeing that Francesco Maria II della Rovere (1549–1631) was the family's last heir and thus without a descendant. This move allowed Berlinghiero Gessi to be named cardinal in 1626 and to cover the role of administrator and apostolic governor of the Rovere territories until 1627. From January 1639 until his death, on April 6 of the same year, he was Camerlengo of the Sacred College of Cardinals.
In this half-bust portrait, Berlinghiero Gessi is seen in a closed environment: a bright red cloth with gilded ornaments serves as a background to the proud figure with the confident gaze of a cardinal, perfectly described in every detail, from the creases and buttons of his outfit to his wrinkled face and gray beard. In this superb and psychologically profound image, Guido Reni proves his skill at making portraits, and at revealing, through human expression, the social and political role of the figure represented.

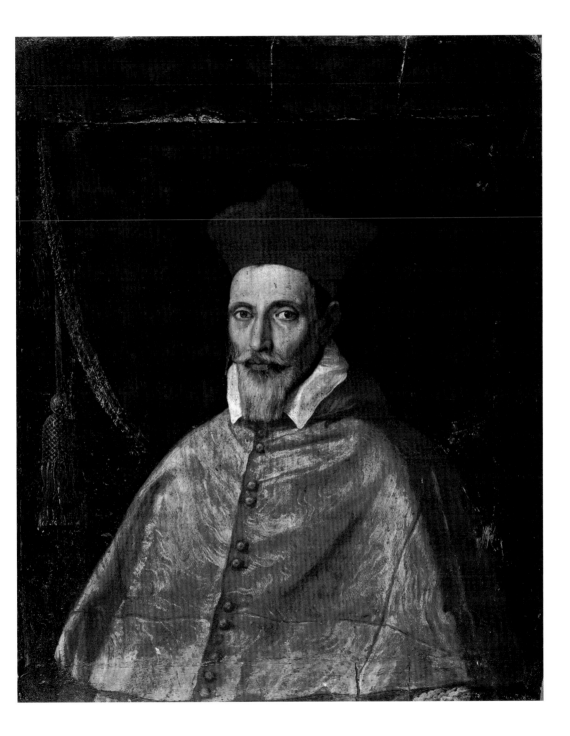

Basilica of Santa Maria Maggiore
The Cappella Paolina

Legend has it that the Basilica, also named Liberiana or Santa Maria ad Nives, was built on the site of the miraculous snowfall of August 5, 356, by Pope Liberius (?–366). Inside it is also one of the most important commissions by the Borghese papacy: the **Cappella Paolina**. Architecturally designed by Flaminio Ponzio (1560–1613), it was completed between 1605 and 1611 for the purpose of containing and safeguarding the icon of the *Salus Populi Romani*, but also to serve as the funeral chapel of Clement VIII Aldobrandini (1536–1605) and Paul V Borghese (1550–1621), the financer and promoter of the entire artistic project. The painters involved in the fresco program, besides Guido Reni, were Giuseppe Cesari, called **Cavalier d'Arpino** (1568–1640), **Giovanni Baglione** (1568–1640), and Ludovico Cardi, called **Cigoli** (1559–1613). The latter artist made the *Immacolata* at the center of the dome, featuring the Virgin with the moon under her feet, reflecting what the artist's friend Galileo Galilei (1564–1642) had observed through his telescope. The sculptural decoration was commissioned from **Silla Giacomo Longhi** (1569–1622), **Nicolas Cordier** (circa 1567–1612), and **Pietro Bernini** (1562–1629), father of the more famous Gian Lorenzo, buried close by near the sacristy. Prior to the two popes mentioned above, Sixtus V (1521–1590) also expressed the desire toward the end of the sixteenth century to be buried in the Liberian Basilica, and for this reason he had a chapel built (1584–1587) by the architect **Domenico Fontana** (1543–1607), and frescoed under the direction of the painters **Cesare Nebbia** (1536–1614) and **Giovanni Guerra** (1544–1618). This sacellum is connected by a staircase to the *oratorio del Presepio* located below, which was moved when the chapel was built, and the place where the relics of the crib were originally located. It is also where the *Presepio* (Nativity Scene) by **Arnolfo di Cambio** (circa 1245–1302/1310) was arranged, now incomplete and held at the Museo del Tesoro Liberiano. Of particular interest inside the papal Basilica are the mosaics in the nave (scenes from the Old Testament: about Abraham, Jacob, Isaac, on the left side, Moses and Joshua on the right), on the triumphal arch (scenes from the childhood of Jesus), and the ones by **Jacopo Torriti** (thirteenth-fourteenth centuries) for the apse (scenes from the life of Mary and the Coronation of the Virgin); also worthy of note is the great relic of the holy crib made by **Luigi Valadier** (1726–1785). The current facade, which covers what remains of the original one executed by Filippo Rusuti (circa 1255–circa 1325), as commissioned by Cardinal Pietro Colonna (1260–1326), was made between 1741 and 1743 by Ferdinando Fuga (1699–1782).

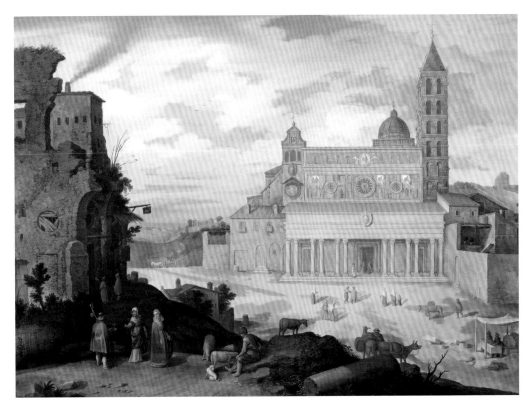

Willem van nieulandt, *View of the Facade of Santa Maria Maggiore*, 1610, Groninger, Groninger Museum.

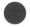 BASILICA OF SANTA MARIA MAGGIORE – THE CAPPELLA PAOLINA
Piazza di Santa Maria Maggiore – 00185, Rome
open every day 7am–6:45pm
the Museo Storico and its undergrounds are open to visitors
during the same hours
(last entry before closing 6:15pm)
+39 06 69886802
www.museo.smm@basilica.va

Frescoes by Guido Reni in the Cappella Paolina

1611–1612, frescoes
Left lunette: *Narses Victorious over Totila and Heraclius Victorious over Chosroes* [on the following pages]
Left arch: *Saint Francis with Two Brothers and Saint Dominic with Two Monks*
Right lunettte: *The Virgin Attaches Saint John Damascene's Right Hand and the Investiture of Saint Ildefonsus*
Right arch: *Saint Cyril of Alexandria and Two Bishops and Saints Pulcheria, Ediltrude, and Cunegonda*

On September 25, 1611, Guido Reni received 100 *scudi* as a down payment for the frescoes that he would make, by June of the following year, in some of the spaces of the Cappella Paolina in Santa Maria Maggiore, whose masonry had been completed just a few months earlier. In his life of the artist published in 1672, Giovanni Pietro Bellori (1613–1696) tells how the painter Giuseppe Cesari, called Cavalier d'Arpino (1558–1640), whom the pope had asked to coordinate the entire decorative program, divided the spaces among the various artists so that Reni would have the hardest areas to fresco. Although the painter was already rather famous in Rome and had a very good reputation with the Borghese, the family of the pope, in the great work site of Santa Maria Maggiore he ended up decorating the smallest spaces: the so-called *sordini*, that is, the four triangular areas to the right and left of the two chapel windows, and the smaller more or less oval spaces of the two large side arches, surrounded by a major stucco decoration. The painter, who had already been trained in Bologna in the difficult art of adapting the content to the complex spaces of the architecture, succeeded in creating some of his finest works here. These were small foreshadowings of the great artistic test that would be the *Apollo in His Chariot Preceded by Aurora* for the Casino Borghese, now Pallavicini-Rospigliosi (see pp. 44–45). In keeping with the grand theme of the entire cycle, Reni represents figures or episodes related to the devotion to the Virgin, as in the case of the Cappella dell'Annunziata at the Quirinal (see pp. 52–53), inserting in the left wall the *Narses Victorious over Totila* and *Heraclius Victorious over Chosroes*, and in the intrados *Saint Francis with Two Brothers* and *Saint Dominic with Two Monks* who flank to the right and to left the *God the Father* in the central oval. Whereas the two saints are easily traced to the figure of Mary thanks to their particular devotion to the Virgin, the two figures next to the window are instead harder to identify, and yet are well suited to the environment built around the miraculous image of the *Salus Populi Romani*. Both General Narses (478–574) and the Byzantine emperor Heraclius (575–641), in fact, managed respectively to defeat and kill Totila, king of the Ostrogoths (circa 516–552), and the Persian emperor Chosroes (circa 570–628), turning to the Virgin and dedicating to her the two great victories that freed Italy from the Ostrogoths, and Jerusalem from the Persians, respectively. The two historical figures, depicted in their battle uniforms alongside the corpses of the enemies they killed after the miraculous apparitions of Mary, offset the two saints painted by Reni on the opposite spaces of the right wall: *The Virgin Attaches Saint John Damascene's Right Hand* and the *Investiture of Saint Ildefonsus*. Akin to the contemporaries Narses and Heraclius, the two church fathers are also closely linked to Mary thanks to the extraordinary miracles and apparitions described by the painter and further made explicit by the inscriptions at the base of the composition. John Damascene (?–750) is represented while an angel reattaches his right hand, previously amputated as punishment for his strenuous opposition to the destruction of the sacred images perpetrated by the Byzantine Empire. Legend has it that the saint offered his cut-off hand to an icon of the Virgin (perhaps rather similar to the *Salus Populi Romani*) without asking for anything in return. From this image a hand to save the mutilated arm is said to have emerged, thus restoring its function. Similarly, Ildefonse of Toledo (607–667), going before an image of the Virgin, along with the members of his confraternity, singing hymns in her honor on the night of December 18, 665, found in lieu of the sacred image Mary

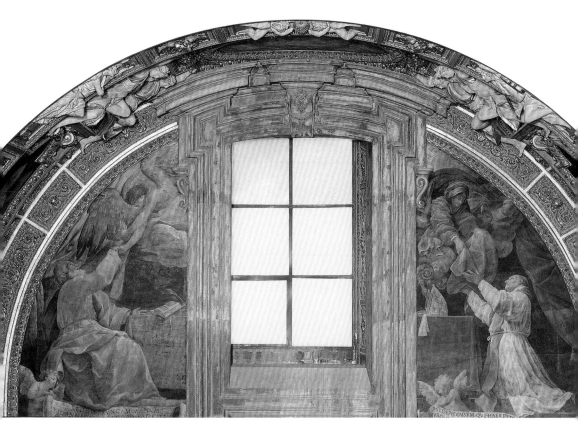

herself. The Virgin, after inviting them to come closer, turned to the Archbishop of Toledo alone, offering him as a gift a precious liturgical vestment, a chasuble, that she herself then imposed on the prelate by consecrating it. Curiously, Reni chose not to use the information contained in the celebratory biographies of the saints in either of the episodes: instead of the Virgin, the painter added an angel to the scene of Saint John Damascene, unlike the traditional story. He made the same changes in the representation of Saint Ildefonse. However, by order of Paul V (1552–1621), Giovanni Lanfranco (1582–1647) replaced the angel with the representation of Mary so that the image would be "in keeping with the truth of the Miracle," according to

Bellori. Reni's contribution to the Pauline work site was completed with the decoration of the spaces of the large right arch, where to the left of the Holy Spirit he portrayed *Saint Cyril of Alexandria and Two Bishops*, the heroic defender of the Virgin's divine motherhood, and to the right *Saints Pulcheria, Ediltrude, and Cunegonda*. Although the painter abandoned the work site for a few months when he suddenly returned to Bologna owing to a dispute the Papal Treasurer concerning payments, he probably did complete the work as early as April 1612, contributing to creating one of the masterpieces of Paul V's papacy. The pope solemnly consecrated the chapel on January 27, 1613, placing the precious icon on the altar where it can still be seen today.

S·ILDEPHVNSVM·QVI·HAERETI
PRO·

REDDIT·TRVNCAM·MANVM
S·IOANNI·

Casino dell'Aurora Pallavicini

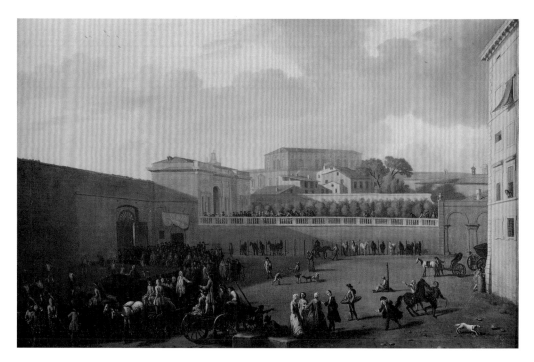

Adrien Manglard, *Playing a Ball Game in the Courtyard of Palazzo Rospigliosi*, 1740, Museo di Roma–Palazzo Braschi.

From 1610 onwards, Cardinal Scipione Borghese (1577–1633) began acquiring pieces of land of what the documents from those days describe as a "garden," that is, a vast green area on which the cardinal commissioned the construction of several non-residential buildings in the area of the Quirinal, known as Monte Cavallo at the time. After various transfers of property, the most important of which is undoubtedly the one that concerned Cardinal Giulio Mazzarino (1602–1661), *Principale Ministro* of King Louis XIV of France (1638–1715), in 1704 it was acquired by Prince Giovanni Battista Rospigliosi and his wife Maria Camilla Pallavicini, the forebears of the current owners.

The most famous among the buildings in Scipione's complex was the Casino dell'Aurora, built to a design by the Flemish architect Jan van Santen (1550–1621) over the ruins of the Baths of Constantine. The pavilion is so named because of the presence of the fresco by Guido Reni on the ceiling in the central room.

The decoration of the Casino is completed by four lunettes representing the *Seasons*, painted by the Flemish artist **Paul Bril** (1554–1626) during the same years that Reni was working on the fresco on the ceiling: in *Autumn* there are several harvest scenes, in *Winter* several Roman monuments are covered with snow, in *Spring* there is a parade of ladies inside a Renaissance garden, while in *Summer* men and animals appear to be overwhelmed by the heat of the Roman countryside. The subjects of the decoration are thus connected to the theme of time passing, as declared by the presence of the hours, the moments in the day, and the seasons. The decorative model is inspired by the celebratory representations of the sixteenth century, when the patron, in this case Scipione Borghese, was celebrated as Apollo, the god who leads the Sun to the Earth every day, as well as the protector of poetry and music. Other works depict the *Triumph of Fame* and the *Triumph of Love,* by the Florentine painter **Antonio Tempesta** (1555–1630), while the cardinal's coat of arms surrounded by cupids is the work of **Cherubino Alberti** (1553–1615). In addition to this central room there are side rooms that were decorated during those same years by **Giovanni Baglione** (1568–1640) and by Domenico Cresti, called **Passignano** (1559–1638).
The cardinal's choice of such different painters and subjects clearly represents the variety of his collecting taste and the close attention he paid to his image as a protector of the arts. Within this context, Guido Reni played the essential role of the painter chosen by the Borghese family as the operative branch of those celebratory politics consisting of images typical of seventeenth-century Roman culture.

CASINO DELL'AURORA PALLAVICINI
Via XXIV Maggio, 43 – 00187, Rome
open only on the first day of the month
open 10am–noon; 3pm–5pm
or by advance booking: +39 06 83467000
aurorapallavicini@hpallavicini.it
www.casinoaurorapallavicini.it

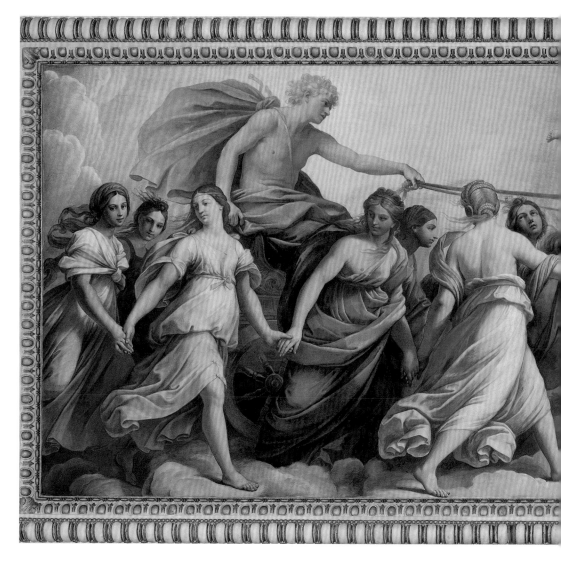

Aurora

by 1614, fresco
280 x 700 cm

The fresco depicts Apollo's chariot preceded by Aurora, the personification of dawn. Aurora is holding in her hands the flowers she scatters as the chariot arrives, announced by the winged cupid holding a lighted torch. He is Phosphorus, the morning star. The chariot of the Sun, driven by the god Apollo, is surrounded by the Horae, dancing maidens arranged in a circle who are a reminder of the passing of the day. In this fresco Reni appears to be the true heir to Bolognese classical painting, whose most important example in Rome is represented by the ceiling in the Galleria of Palazzo Farnese that was executed by the Carracci in the early part of the century. This element can especially be identified because of the use of light, brilliant hues, and the presence within the composition of monumental figures moving in perfect harmony.

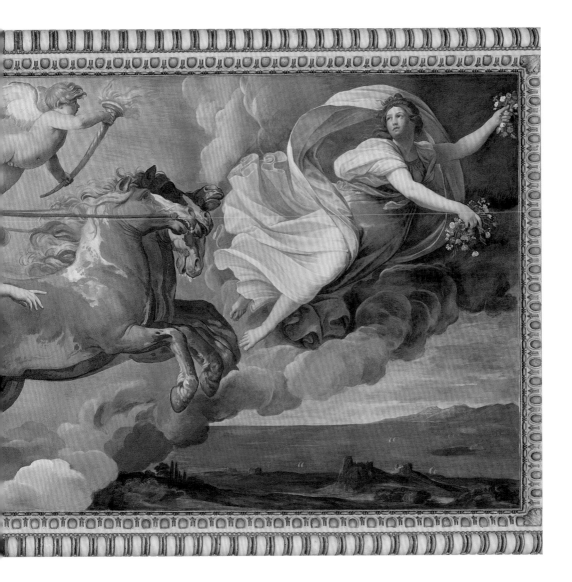

Istituto Poligrafico dello Stato, Commemorative issue
on the occasion of the four hundredth anniversary of the birth
of Guido Reni (engraver T. Mele), 1975.

GUIDO RENI: FROM BOLOGNESE PAINTER TO "DIVIN GUIDO"

The great Emilian master was one of the most highly esteemed painters of all time, not only by the seventeenth-century artists, poets, and biographers, but also and above all by the literati, critics, and travelers who, in the centuries that followed, had the chance to listen to anecdotes about the Bolognese artist as well as to admire and love his works. Much of the artist's fame is linked to recollections that made up the underlying story told in the biography written by his fellow citizen Carlo Cesare Malvasia (1616–1693), who in 1678 published *Felsina Pittrice*, a work dedicated to the lives of the Bolognese artists. The opinions on Guido Reni were not always positive ones, like that of the English poet Percy Bysshe Shelley (1792–1822), who said that if the city of Rome had been completely destroyed his only regret would be the loss of the works of Raphael and Reni; sometimes they were rather negative as well, like those of the English writer John Ruskin (1819–1900), or the young Lithuanian-born, naturalized Italian art historian Bernard Berenson (1865–1959).

The most interesting testimonies are the ones that describe the moving, profound, and emotional reactions before Guido's paintings, like those of the French writer and nobleman known as the Marquis De Sade (1740–1814), or of the English intellectual John Addington Symonds (1840–1893). Not to mention the sense of awe felt by the German poet Johann Wolfgang von Goethe (1749–1832), who for the first time ever saw in Reni's paintings a different way of painting, the great style of the Italian Seicento, so rich in beauty and characterized by the complexity of the composition, which preceded the Baroque age.

While at first the Bolognese painter was described in the treatises and by the art experts as the "Divin Guido", for other countries, for example, highly refined late seventeenth-century France, Reni was simply *Guido*, with no further need for characterization or epithets. He continues to remain as such today.

Thanks especially to the great publications addressed to a general audience and to some major exhibitions, over the course of the twentieth century Guido's styles, colors, and personality have been brought to the attention of many, and even celebrated with a postage stamp on the occasion of the four hundredth anniversary of his birth (1575–1975). The work chosen for that occasion was a detail from the *Aurora*, symbolizing the highest form of art and beauty reached by Reni during his first Roman period (see the dedicated analysis on pp. 44–45).

Quirinal Palace

Since the Middle Agese, the Quirinal Hill was an area, at the time on the outskirts of the city, where Roman patrician families would erect their residences, sorrounded by many towers and churches.

From the fifteenth century, the building projects gradually expanded until 1550, when the villa of Cardinal Oliviero Carafa (1430–1511) was leased by Cardinal Ippolito d'Este (1479–1520). He was the first to turn it into a residence filled with open spaces with fountains and elaborate gardens graced with antique sculptures. Pope Gregory XIII Boncompagni (1502–1585) decided to modernize the Este complex, commissioning the works for its enlargement to the architect Ottaviano Mascarino (1536–1606). It was Sixtus V Peretti (1521–1590) who definitively acquired the property of the villa in order to turn it into the papal summer residence.

The high point of the project was reached during the reign of Paul V Borghese (1552–1621), who entrusted first to Flaminio Ponzio (1560–1613) and then to Carlo Maderno (1556–1629) the realization of the wing of the palace that contained the Staircase of Honor, the Sala del Concistoro (today's Salone delle Feste), the Salone dei Corazzieri (once Sala Regia), the papal apartments, and the Cappella Paolina and the Cappella dell'Annunziata. Over the course of the seventeenth century the palazzo was constantly transformed. Not only were its defensive elements renewed—the low tower on the facade and the lodgings that were used for the Swiss Guards were both built at the time—but its residential and reception areas were as well. In 1638 Gian Lorenzo Bernini (1598–1680) was commissioned to design the *Loggia delle Benedizioni* above today's main entrance. The current exterior of the Quirinal Palace, fondly referred to as the *manica lunga* (long sleeve) because of its significant dimensions, is the result of the last important architectural changes that were completed by the first half of the eighteenth century by Alessandro Specchi (1666–1729) and Ferdinando Fuga (1699–1782).

The building remained property of the popes until the Kingdom of Italy was established, when it became, at first, the residence of the Savoy royal family, and, later, the seat of the President of the Republic.

Giovanni Battista Falda, *View of the Principal Facade of the Quirinal Palace*,
1665–1739, from *Il Nuovo teatro delle fabriche et edificii in prospettiva
di Roma moderna*, Paris, Bibliothèque nationale de France.

 QUIRINAL PALACE
Piazza del Quirinale – 00187, Rome
advance booking required:
+39 06 39967557
www.palazzo.quirinale.it

Cappella dell'Annunziata

1609–1611, frescoes
a. Cupola: *Assumption of the Virgin Crowned by God the Father* [on the following pages]
b. Pendentives: *Isaiah and Solomon* (the *David and the Moses* were painted by the workshop of Giovanni Lanfranco)
c. Arch: *God the Father in Glory with Angels*, 425 x 180 cm
d. *The Virgin Sewing (The Virgin Mary Sewing in the Temple)*, 210 x 200 cm [on the following pages]
e. *The Nativity of the Virgin*, 360 x 335 cm [on the following pages]
f. *Seven Putti* (the other section of the chapel painted with the same subject is by Francesco Albani)
g. Altarpiece: *Annunciation*, 1609–1610, oil canvas, 200 x 350 cm

This small chapel was built as a private space for Paul V (1552–1621) where he could personally and privately devote himself to the Virgin Annunciate. Guido Reni was commissioned to both organize the works and direct the entire decorative program. The work was in turn commissioned from a team of painters, including Francesco Albani (1578–1660), Antonio Carracci (1583–1618), and Giovanni Lanfranco (1582–1647). On the left wall is an inscription where the date 1610 is recalled as being the end of the works, while the archive documents bear witness to how the work site was actually extended between 1609 and 1611.

The theme chosen for the paintings in the chapel is the life of Mary, the same as the frescoes in the Cappella Paolina (see pp. 40–41), the most important episode of which is represented in the altarpiece depicting the *Annunciation*. In this canvas Guido Reni experimented with a new form of classicism, midway between the figures inspired by the antiquity of the Carracci and the dramatic light and dark of Caravaggesque style.

Foreshadowing the crucial event of the narrative are the frescoes in the cupola portraying *God the Father*, with *Moses, David, Solomon,* and *Isaiah* watching from the pendentives. Arranged all around them are *Adam*, three *Patriarchs*, the *Theological Virtues* (Faith, Hope, and Charity) and the *Cardinal Virtues* (Prudence, Justice, Fortitude, and Temperance), to which are added three other female allegorical figures. Represented on the main walls, in the form of large lunettes, are four episodes in the life of the Virgin: from the right, the *Annunciation to Joachim*, the *Nativity of the Virgin*, the *Presentation of the Virgin in the Temple*, and the so-called *Virgin Sewing*. This last fresco particularly underscores the intimate and private function of the chapel, seeing that the subject is closely linked to the everyday life of the young Mary, and based on a previous painting that Reni had given to Paul V. Although the general idea for the frescoes is attributed to Guido's mind, not all the paintings are by him. Among the wall paintings only the *Nativity of the Virgin*, the *Madonna Sewing*, and the *God the Father* would seem to be autographs by the Bolognese painter. Indeed, in these paintings Reni achieves one of the highest points in the painting from his Roman years, visible in the clear rendering of the sentiments and in the moralizing monumental and ideal expression. Two other elements further underscore the private nature of the chapel: the interior path that connects this space to two rooms at the back, planned so that the pope would not be seen, and the door with grates separating the area of the presbytery from the rest of the chapel, installed during the papacy of Urban VIII (1568–1644) and recently repositioned after restoration work. The current appearance of the chapel, except for the floor that was installed in 1815 at the behest of Pope Pius VII Chiaramonti (1742–1823), remains the original one, although during the Kingdom of Italy this sacred space was used to wash kitchenware while banquets were being held in the adjacent rooms.

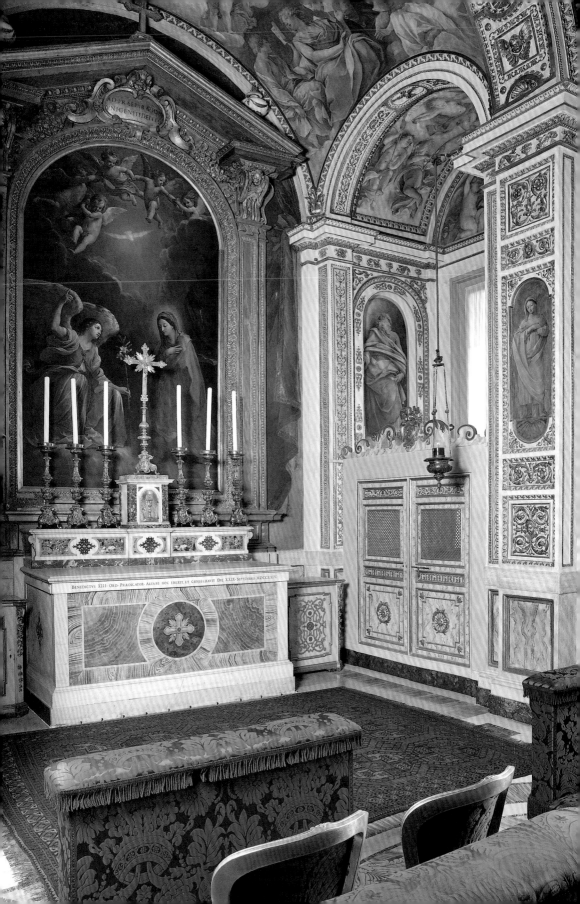

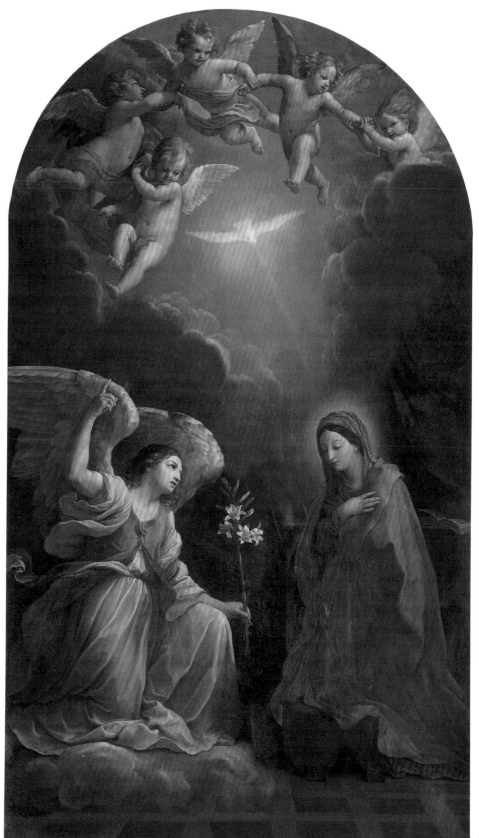

a.

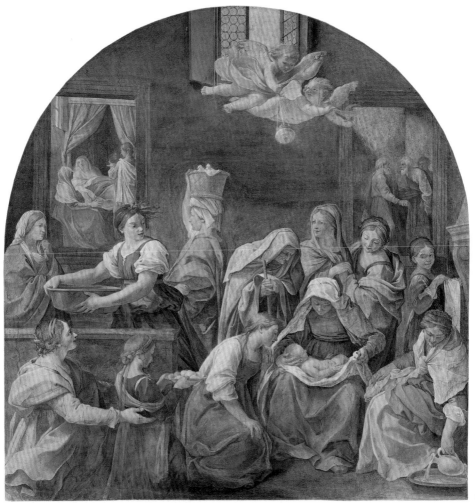

e.

d.

55

Galleria Colonna

In the twelfth century the Colonna family began settling in the area close to the Basilica dei Santi Apostoli, where the relics of Saints Philip and James the Less were kept under the high altar. As time went by, all the properties they acquired were unified in a single building at the behest of Giordano Colonna (?–1422), the older brother of Oddone, who in 1417 would be elected pope taking the name of Martin V (1369–1431). The pope himself chose the family palace as his residence after refurbishing it so that it could fittingly host himself and his court. Most of the large building's current appearance, including the wing of the palazzo that hosts the painting gallery, was built between 1654 and 1665 at the behest of Cardinal Girolamo (1604–1666), and later enlarged by Lorenzo Onofrio Colonna (1637–1689) and his wife Maria Mancini (1639–1715), one of the five famous nieces of Cardinal Giulio Mazzarino (1602–1661). As early as 1610, the palazzo hosted a theater designed by the architect Girolamo Rainaldi (1570–1655).

The architectural space of the gallery was conceived as the place that would be used for receptions and celebrations by Marcantonio II Colonna (1535–1584), represented in his actions as Admiral of the Papal Fleet that defeated the Turks at Lepanto in 1571.

The focus of the visit is the *Sala Grande*, characterized by the elegant and refined mirrors painted by **Mario dei Fiori** (1603–1673), **Giovanni Stanchi** (1608–circa 1675), and **Carlo Maratta** (1625–1713), and by the cannon ball that is still today in the place where it landed after being fired from the Janiculum by the French army at the time of the Roman Republic.

Among the works preserved in the Galleria, in addition to the sumptuous furnishings, there are paintings by sixteenth-century masters such as **Bronzino** (Agnolo di Cosimo, 1503–1572) and a very interesting collection of landscapes with paintings by **Gaspard Dughet** (1615–1675), **Francesco Albani** (1578–1660), **Ludovico Pozzoserrato** (circa 1550–1604/1605), and **Salvator Rosa** (1615–1673); the seventeenth century is represented by masterpieces such as *The Beaneater* by **Annibale Carracci** (1560–1609), *Time Abducting Beauty* by **Cavalier d'Arpino** (1568–1640), *Saint Francis Praying* by Guido Reni, *Saint Charles Borromeo* and *Magdalene in Glory Held up by Angels* by **Giovanni Lanfranco** (1582–1647), and *The Guardian Angel, Moses with the Tables of the Law*, and *Saint Paul the Hermit* by **Guercino** (1591–1666).

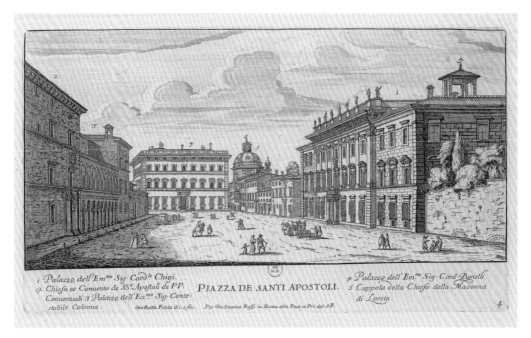

Giovanni Battista Falda, *Piazza Santi Apostoli*, 1665–1739, from Il *Nuovo teatro delle fabriche et edificii in prospettiva di Roma moderna*, Paris, Bibliothèque nationale de France.

 GALLERIA COLONNA
Via della Pilotta, 17 – 00187, Rome
open only on Saturday
from 9:15am–1:15pm
for advance booking: +39 06 6784350
info@galleriacolonna.it
www.galleriacolonna.it

Saint Francis in Prayer with Two Angels

Circa 1631
Oil on canvas, 196 x 117 cm

Although Guido Reni left Rome in 1614 to settle permanently in his beloved Bologna, his relationship with the eternal city and its prestigious patronage never ceased. During his increasingly sporadic returns to the capital, or directly from Bologna, the master obtained numerous commissions, which once completed were sent to the papal city. The noble Roman families continued to turn to him for works to be placed in both public and private spaces. A case in point is the canvas depicting *Saint Francis Praying with Two Angels* in the Galleria Colonna, which was likely commissioned from the painter by Girolamo I Colonna (1604–1666), a Roman ecclesiast, who from 1632 to 1645 held the post of metropolitan archbishop of Bologna. The canvas, which is mentioned in the inventory of the cardinal's estate from 1648, must have been directly requested by the prelate on the occasion of the Bolognese celebrations for the end of the plague. The figure of Saint Francis is a reproduction of the same saint portrayed at the center of the votive standard in silk (known as the *Pala della Peste*) made by Reni between the end of 1630 and the early months of 1631. This work was commissioned by the Bolognese Senate and is now in the Pinacoteca Nazionale in Bologna. Based on the same idea that he had developed for the public standard used for the annual procession through the streets of Bologna, Reni isolates the figure of the poor man of Assisi and creates a new composition. By replacing the figure of Mary with the two angels and situating the saint in a small cavern, the painter succeeded in keeping the same figure he had conceived for the large-scale Bolognese standard, transforming it into a work of private devotion. Along with the monumental *Pala della Peste*, the *Saint Francis* at the Galleria Colonna marks a turning point in the painter's activity. It was from these very canvases that Guido Reni changed his style, increasingly approaching brighter colors and a lighter palette, elements that would prevail in the works he made in his final years. In spite of this, the canvas at the Galleria Colonna is still an open declaration of the monumentality of the figures and the classicism of the forms that the artist had learned about in Rome, which also make this composition one of the artist's most successful ones, as witnessed by the numerous copies and engravings executed after this image of a seraphic Francis. The simplicity of the scene produced with just a few emblematic objects embracing the entire Franciscan experience is indeed a symbol of the clarity and limpidness that continued to characterize Reni's canvases. The skull, the simple cross, the rosary, the modest meal in the foreground, the worn habit, the aridity of the cavern, and the ecstatic and compassionate face of the saint contribute to making this canvas one of the works that best interprets the request for simple, instructive painting imposed by the Church at the height of the seventeenth century.

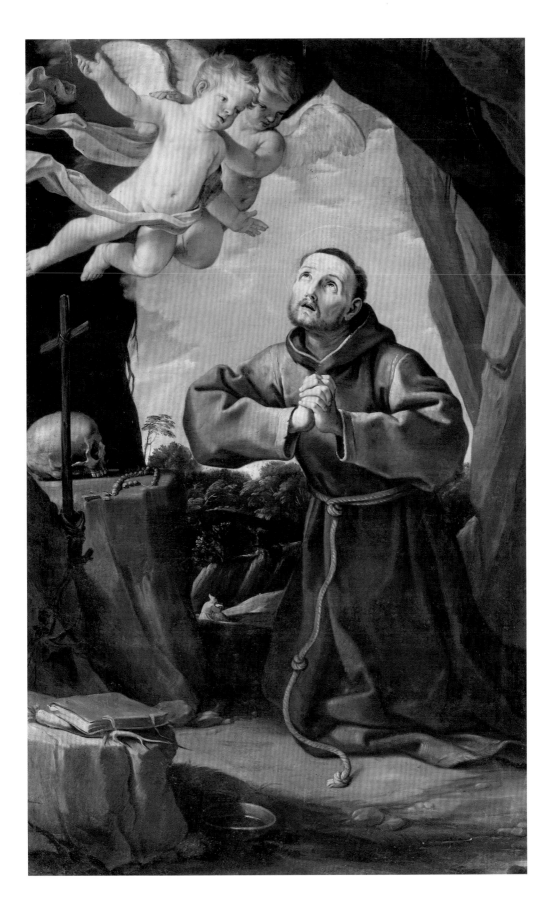

Accademia Nazionale di San Luca

Pierfrancesco Alberti, *An Academy of Painters*, 1600–1638, New York,
The Metropolitan Museum of Art.

Founded in 1593 by the Marchigiano painter **Federico Zuccari** (1539–1609),
who was appointed its first *Principe*, the mission of the Accademia di San Luca
was to raise the role that had been given to the artists, who until then had been
considered simple artisans. The institution was named after Luke the Evangelist
who, according to legend, had made the first portrait of the Virgin Mary. Precisely
for this reason, the original official seat of the Academy was the church of Santi
Luca e Martina at the Roman Forum, built from 1635 by **Pietro da Cortona**
(1597–1669) after the miraculous discovery of the relics of the titular saint,
now held in the building's very elaborate underground chambers completely
decorated with polychrome marbles.

Starting from 1934, the seat of the Accademia Nazionale di San Luca was
relocated to Palazzo Carpegna, built between the late sixteenth and early
seventeenth centuries by a follower of Giacomo Della Porta (1532–1602). In
1630, the building was acquired by Count Ambrogio di Carpegna (1602–1643),
who decided to have it enlarged and remodeled, commissioning the works from

Francesco Borromini (1599–1667). The patron was not able to see the results of his project to modernize the building, which was completed between 1643 and 1650 to a lesser degree by his brother, Cardinal Ulderico Carpegna (1595–1679). The Ticino architect's work is recognizable in the entrance door and in the outer arcade, characterized by the presence of elegantly crowned festoons of flowers and laurel, and on the door inside by a marvelous winged head of the Medusa, surrounded in turn by cornucopias brimming over with fruit, symbolizing good fortune and fertility.

On the third floor of the building is the Academy's rich collection of paintings, which was assembled between the seventeenth and eighteenth centuries. The collection boasts a considerable number of portraits and self-portraits, which the institution asked the artists to donate when they were nominated. In addition to these, there are numerous other works from private donations, the results of contests organized by the Academy, as well as a group of paintings from the Pinacoteca Capitolina: worthy of note are a *Satyr and Nymph*, probably a late sixteenth-century copy of a painting by the Ferrarese artist **Dosso Dossi** (circa 1468–1542), a *Putto* and a detached fresco portraying *Saint Luke Painting the Virgin*, both traditionally attributed to **Raphael** (1483–1520), *Susanna and the Elders* by **Palma the Younger** (Jacopo Negretti, 1549–1628), *Perseus and Andromeda* and the *Taking of Christ* by **Cavalier d'Arpino** (1568–1640), the *Virgin and the Angels* by **Antoon van Dyck** (1599–1641), the *Nymphs Crowning the Goddess of Abundance* by **Pieter Paul Rubens** (1577–1640), and the *Triumph of Bacchus* by **Nicolas Poussin** (1594–1665), a copy after a painting by Titian.

Works by Guido Reni

Fortune with a Crown
circa 1636–1637, oil on canvas, 160 x 129 cm

Bacchus and Ariadne
circa 1640, oil on canvas, 284 x 419 cm

ACCADEMIA NAZIONALE DI SAN LUCA
Piazza dell'Accademia di San Luca, 77 – 00187, Rome
Monday–Saturday (closed Sunday)
open 9am–6pm
for advance booking:
segreteria@accademiasanluca.it
galleria@accademiasanluca.it
www.accademiasanluca.eu/it

Bacchus and Ariadne

Circa 1640
Oil on canvas, 284 x 419 cm

In 1637 Urban VIII Barberini (1568–1644) commissioned from Guido Reni a work that was much more important from a political standpoint than an artistic one. The pope, along with his cardinal nephew, Francesco Barberini (1597–1679), invited the Bolognese painter to make a monumental canvas that would be sent as a gift to the highly sophisticated Henrietta Maria of Bourbon (1609–1669), the Catholic consort of the King of England Charles I Stuart (1600–1649). The work was intended to represent the mythological tale of Ariadne. After being abandoned by Theseus on the island of Naxos, Ariadne welcomes the arrival of Bacchus, who is accompanied by Venus and followed by the customary procession of sprightly putti. Conceived as a decoration for the ceiling of the royal couple's bedchamber in the Queen's House of Greenwich, the painting was also meant to serve as a tool to re-establish relations between Anglican England and the Church of Rome. The theme of the meeting between the two mythological figures was to be interpreted as a "pretty" allegory of a possible new union between the Catholic and British Anglican worlds. Perhaps because of all the attention surrounding the work, the start of its production was especially slow, preceded by a long discussion on the iconography, and on the problems in the relationship between Guido Reni and Francesco Albani (1578–1660), who was also supposed to participate in the undertaking. After overcoming the disagreements between the two painters, which resulted in Albani's withdrawal, Reni painted the large-scale canvas in Bologna under the watchful eye of the Cardinal Legate Giulio Sacchetti (1587–1663), completing it with the help of his collaborators and sending it to Rome around September 1640. The painting's arrival in Rome rekindled the discussions on its contents, to the extent that the cardinal nephew himself described it as "lascivious" and an occasion for scandal before the "heretics" in England. The new doubts on the contents of the painting and the dramatic developments of the Puritan Revolution in England prevented the painting from leaving the country and therefore being given to the Queen. The interruption of diplomatic relations, the beheading of Charles I, and Henrietta's adventurous escape to France kept the painting from departing until around the late 1640s. It finally ended up in the hands of the exiled sovereign around 1650, but she soon had to sell it due to economic hardship, and was acquired by Michel Particelli d'Hémery, Surintendant des Finances of the Kingdom of France. At this point the history of the painting becomes blurred; however, the biographer Malvasia (1616–1693) recounts that the financier's wife, who could no longer bear what she considered to be the excessive nudity in Reni's painting, had the canvas cut up. The surviving pieces were then sold. This complex story helps us to understand how the beautiful replica of the work in the Accademia di San Luca bears precious witness to the extraordinary masterpiece that is currently only known of through the sources and various copies. In spite of its being a highly controversial object, Reni's painting was extremely successful from early on, both in Bologna and in Rome. The expressive power of the bodies, the limpid, saturated colors, the classical poses, and the clarity of the forms transformed the canvas into a triumph, encouraging Reni himself, along with his collaborators, to make complete or partial copies of it to be put on the market, which was always keen to receive the artist's creations. The Roman canvas, for instance, is the replica of the central part of the original work, probably made in Bologna—before the original was sent to Rome—by Guido himself along with Antonio Giarola, called Veronese (1597–1674) and Giovanni Andrea Sirani (1610–1670), his closest collaborators in the final years of his career. This copy, which was probably commissioned by Cardinal Sacchetti, was among the first canvases owned by the Pinacoteca Capitolina (see pp. 102–103), and in 1845 it was sent to the Academy so that it could be included in the "Gabinetto Riservato" dedicated to paintings deemed overly sensuous.

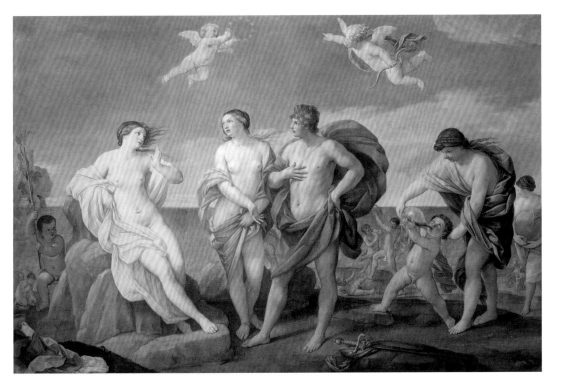

Museo Nazionale del Palazzo di Venezia

Built between 1455 and 1467 at the behest of Cardinal Pietro Barbo (1417–1471), Palazzo Venezia is perhaps the first great Renaissance example of civil architecture in the papal city. Initially conceived as a residence for the Venetian prelate, the complex was transformed into a papal palazzo when Barbo was elected pope, taking the name of Paul II. The nearby basilica of San Marco was englobed and renewed as well. Passed on to Cardinal Lorenzo Cybo (1450/1451–1503), who completed both the Sala Regia and the Sala del Mappamondo, and after that to Paolo III Farnese (1468–1549), who refurbished the previous owner's living quarters by enlarging them and adding a chapel, in 1564 Pius IV Medici di Marignano (1499–1565) donated the palazzo to the Republic of Venice, which used it as its embassy. Over the centuries, the new owners to which Palazzo Venezia owes its name repeatedly modified the building until 1797, when it became property of the French State. In 1814 Palazzo Venezia became the Roman seat of the Austrian Embassy. Confiscated by the Italian Government in 1916, the building was the object of major restoration work (1924–1930) so that it could serve as a museum and headquarters of institutes like the National Institute of Archaeology and Art History together with its prestigious library. The building's aristocratic spaces, as well as its proximity to the nineteenth-century Altare della Patria monument that had resulted in the radical and monumental transformation of the area opposite the building, favored the choice of the palazzo as the seat of the Fascist Grand Council between 1924 and 1943. After the Second World War, the building was once again used for cultural purposes. In addition to the aforementioned national library, today Palazzo Venezia hosts the diverse collections of the Museo Nazionale, a museum originally meant to house the applied arts collection coming from bequests, donations, and acquisitions, as well as older collections, such as those from what what was once the Museo Kircheriano—founded in 1651 by the Jesuit Father Athanasius Kircher (1602–1680) in the nearby palazzo of the Collegio Romano—or from the 1911 Universal Art Exposition, initially hosted in Castel Sant'Angelo. At the Museo Nazionale in Palazzo Venezia visitors can admire paintings, sculptures, majolicas, furnishings, terracottas, weapons, porcelain, and glassware, and learn about the arts from the thirteenth to the seventeenth centuries. They will also be able to admire iconic works like the *Stories of Saint Jerome* by **Mino da Fiesole** (1429–1484), the *Double Portrait* attributed to **Giorgione** (circa 1478–1510), the *Saint Peter Weeping* by **Guercino** (1591–1666), as well as the renowned *Terracina Chest*, a rare piece of furniture from the tenth-eleventh centuries.

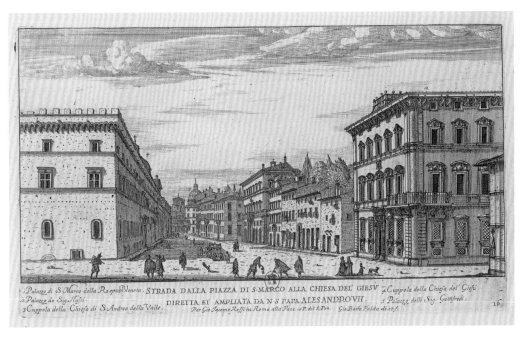

Giovanni Battista Falda, *View of the Facade* (engraving) from *Il Nuovo Teatro delle Fabbriche*, in *Il Nuovo teatro delle fabriche et edificii in prospettiva di Roma moderna*, Paris, Bibliothèque nationale de France.

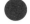 MUSEO NAZIONALE DEL PALAZZO DI VENEZIA
Piazza Venezia, 3 – 00186, Rome
open every day 9:30am–7:30pm (last entry before closing 6pm)
www.museopalazzovenezia.beniculturali.it

Head of an Old Man (Slave of Ripa Grande or Seneca)

By 1614
terracotta, 37 cm

Carlo Cesare Malvasia (1616–1693), in the biography he dedicated to Guido Reni in *Felsina Pittrice*, reminds the reader that the Bolognese artist was also an extraordinary master in the art of sculpture. Interrupting his description of Guido's career and paintings, the biographer states that: "He made sculpted reliefs and was good at it, like the famous head called *Seneca*, which does the rounds of all the schools, and that he sculpted after a Roman slave that he found in Ripa, shaping and imbuing it with this guise." Although Malvasia described Reni's head of Seneca as a famous and highly successful work, it is lost to this day. Its absence does not undermine our knowledge of the famous piece, however, which already in the late seventeenth century had spawned multiple copies in the places where young artists were trained, as mentioned by the biographer himself ("which does the rounds of all the schools"). The *bella* or good version, now at the Museo Nazionale di Palazzo Venezia, is one of the most valuable testimonies, probably executed after Reni's model by a Roman sculptor by the end of the seventeenth century. The terracotta work represents an elderly man gazing upwards during a moment of tension and strain, his lips parted and the nerves in his neck tense. The entire surface, shaped with extreme precision and great mastery, is furrowed with deep wrinkles that strongly characterize the figure, albeit without reducing it to a caricature or a grotesque image. According to the biographer, the work was made by copying the true appearance of a *schiavone*, that is, a man of Dalmatian origin usually doing physical labor at the river dock of Ripa Grande, south of Rome. The sculpture was likely made during Reni's early Roman period: a turning point in his artistic output when he encountered the naturalistic style of the Caravaggesque world after having received classical training at the Accademia dei Carracci in Bologna. Starting from the actual observation of the head of the Dalmatian dock worker, the artist did not wish to simply make a sculpture representing this man with all the traces that time and hard work had left on his body. He also wished to create a model that could be reproduced in drawings and paintings. It is hardly surprising, then, that there are numerous Renian drawings of this head, or that the Galleria Spada holds a canvas, also attributed to Guido, depicting the so-called *Slave of Ripa Grande*, probably made before the artist's departure from Rome, just like the original sculpture. In the small canvas the painter studies the effects of the light on the figure, which makes this painting a training tool as well as Reni's personal contribution to the debate under way on the Roman art scene at the time, between the imitation of antiquity and the copy after life. As the critics have recently pointed out, through his sculptural creation and its subsequent graphic re-elaboration, Reni seems to want to emphasize the importance of copies and of academic training. Nevertheless, academic study cannot accurately copy the antique world and compare it to the clear representation of reality; rather, it must start from the natural element and eventually correct it by observing the fundamental classical models. It is a new process that sees in these two works—the bust in Palazzo Venezia and the painting in Galleria Spada—Reni's first steps, that is, when the artist was conducting his first natural studies as he waited to undertake that process of re-elaboration, study, and assimilation that would idealize the simple portrait of a dock worker in the face of the ancient philosopher Seneca. Arguably, the identification with the figure of Seneca did not occur until later, when Reni, by then headed down the path of ideal beauty (see, for instance, the *Saint Michael* in the church of the Cappuccini, pp. 24–25), deliberately modified the title in order to bring the work closer to those representing the philosopher in the mid-seventeenth century, at the heart of particular critical acclaim. The bust would remain extraordinarily successful, as proven by the one in Palazzo Venezia belonging to the collection of the sculptor and copyist Bartolomeo Cavaceppi (1715–1799), and later to that of the Marchese Giovanni Torlonia (1873–1938).

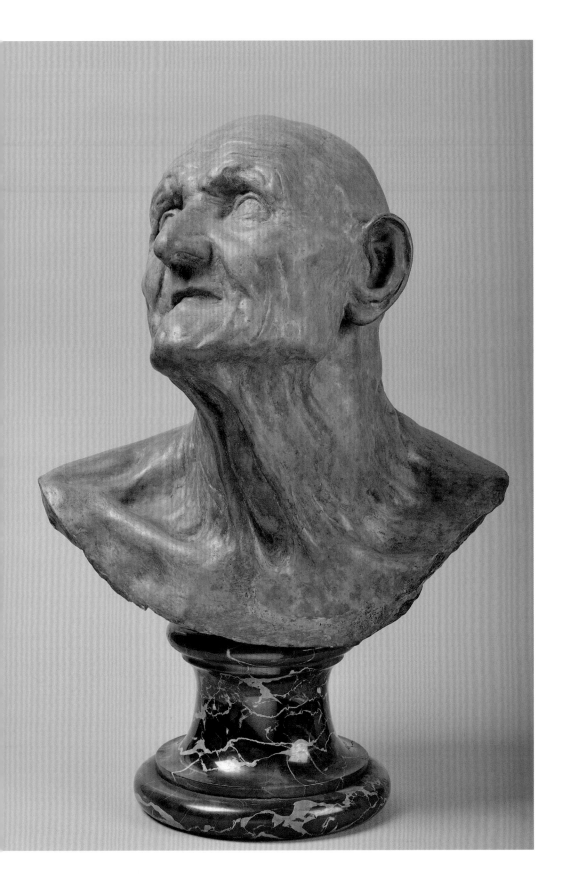

Church of San Carlo ai Catinari

Built over a pre-existing twelfth-century church dedicated to Saint Blaise, in 1575 Pope Gregory XV Ludovisi (1554–1623) decided to donate it to the Order of the Clerics Regular of Saint Paul, after which it was reconstructed by the Barnabites, in honor of Saint Charles Borromeo, to a design by the architect Rosato Rosati (1559–1622) between 1612 and 1620. The building was completed with a travertine facade, designed by the architect Giovanni Battista Soria (1581–1651), between 1636 and 1638. Its name, which initially also referred to the saint to whom the church was devoted, is based on the fact that there were many shops that made wooden basins (*catini* in Italian) in that area at the time.

The painted decorations were executed starting from the 1620s: in 1627 the pendentives in the cupola with the *Cardinal Virtues* were painted by **Domenichino** (1581–1641), the frescoes on the counterfacade depicting the *Charity of Saint Charles Borromeo* and *The Mission of Saint Charles Borromeo against Heresy* (1641–1642) were made by the brothers **Gregorio** (1603–1672) and **Mattia Preti** (1613–1699), while the apsidal conch featuring the *Glory of Saint Charles* was painted by **Giovanni Lanfranco** (1582–1647) in 1646. Also worthy of note is Lanfranco's *Annunciation* (1624), *The Mocking of Christ* by **Cavalier d'Arpino** (1568–1640), *Saint Charles Borromeo Carrying the Holy Nail in Procession* (1650) by **Pietro da Cortona** (1597–1669), and the bronze *Crucifix* in the Sacristy attributed to **Alessandro Algardi** (1598–1654).

Giovanni Battista Falda, *View of the Facade of the Church of San Carlo
ai Catinari*, 1665–1739, from *Il Nuovo teatro delle fabriche et edificii
in prospettiva di Roma moderna*, Paris, Bibliothèque nationale de France.

CHURCH OF SAN CARLO AI CATINARI
Piazza Benedetto Cairoli, 117 – 00186, Rome
open every day 7:30am–noon; 4pm–7pm
www.sancarloaicatinari.wordpress.com

Saint Charles Borromeo

1614
Detached and cut fresco

Canonized on November 1, 1610 by Paul V Borghese (1552–1621) in Saint Peter's, Saint Charles Borromeo (1538–1584) instantly became one of the most popular saints among those of the Counter-Reformation. This detached fresco, now in the sacristy of the church devoted to him, is interesting and early proof of this. The picture was painted by Guido Reni between 1612, the year the reconstruction of the church first began, and 1614, when the painter left Rome to return to his native Bologna. The fresco was probably commissioned by Giovanni Ambrogio Mazenta (1565–1635). Mazenta was an architect and general of the Order of the Barnabite Fathers, a congregation that was particularly close to the Lombard saint, whom it chose as its second protector because of the numerous merits he had acquired in life vis-à-vis the congregation. The image of devotion was originally located outside and "above the entrance door" to the new church; a location that in addition to being recorded in one of the most famous guidebooks to seventeenth-century Rome—*Viaggio per Roma* by the papal physician Giulio Mancini (1559–1630),—is further proven by the foreshortened view of the figure, which was particularly suited to observing it from below as the faithful would have done before entering the place of worship. Reni portrayed the venerable prelate with his hands together as he prays and gazes heavenwards, thereby mirroring the way the devout gazed upwards at the saint hoping for his intercession. The composition faithfully reflects the theological idea of the Barnabites, and it soon circulated as the first devotional image after the prelate was canonized. However, Reni reinterprets the traditional profile view of the praying saint by choosing a half-bust and slightly turned pose of the holy man dressed in his cardinal clothes. Reni also paid close attention to the facial features which would make the image of the cardinal among the easiest to recognize by the illiterate. In this image of a man with short hair, a tall forehead, a dark complexion, and the hooked nose he was known for, Reni created an iconic image of extraordinary devotional success that still maintains all its force. However original the composition may have been, it still allows us to glimpse Reni's tendency to repeat his studies of figures, faces, and compositions. This specific case alludes to other works preserved in Rome, for instance, the *Slave of Ripa Grande* at the Galleria Spada (see the description on pp. 66–67). Hence, the painting was highly successful from the moment it was executed. This resulted in its being detached from the wall when the church was completed with an elaborate travertine facade between 1636 and 1638. The conservation of this work, first in the presbytery and later in the sacristy, allows for a reconstruction of the artist's final activity before he left Rome, where he continued to return sporadically and for short periods of time.

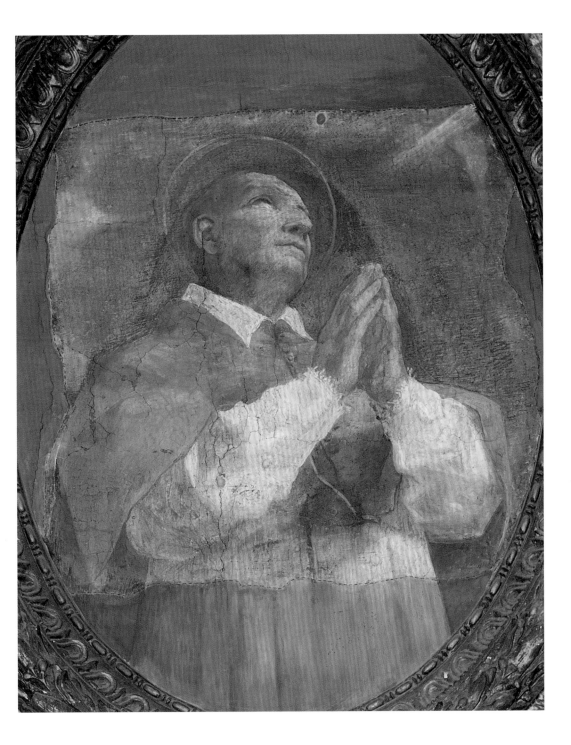

Church of the Santissima Trinità dei Pellegrini

In 1558 Pope Paul IV (1476–1559) entrusted the ancient church of San Benedetto in Arenula, recorded since the twelfth century, to a congregation of lay members that had been recognized by the papal authority only a few years earlier with the name of *Fraternity of the Holy Trinity of Pilgrims and Convalescents*. Although the lay order was not created until 1548, inspired by Saint Philip Neri (1515–1595), in less than two decades it had managed to impose itself on the complex mid-sixteenth-century Roman society, growing in terms of its followers and economic strength. Therefore, it should come as no surprise that in 1579, just two decades after the concession, Gregory XIII (1502–1585) bequeathed the temple to the Confraternity, which decided to tear it down for the purpose of building a larger and safer structure. The church's construction to a design by Paolo Maggi (circa 1561–1613), beginning on February 26, 1587, was not consecrated until June 1616, and was finally finished in 1723 with a facade by Francesco De Sanctis (1679–1731). In spite of the many years required to complete its construction due to the constant interruptions and the loss of the title of parish in 1601, from the early seventeenth century the new church named after the Holy Trinity was the subject of an interesting decorative campaign that involved Late Mannerist works as well as the first experiments in the Baroque style. While **Giovanni Battista Ricci** (circa 1537–1627) was commissioned to paint the *Stories of Saint Julius* in the third chapel to the right, the Evangelists on the corbels of the cupola, and the canvas framing the Marian image with *Saints Joseph and Benedict* (circa 1616) on the left crosspiece, the **Cavalier d'Arpino** (1568–1640) instead executed the *Virgin and Child with Saints Augustine and Francis* in the second chapel to the left owned by the Parisi family. A church from the beginning of the century that through sculpture, as the *Saint Matthew and the Angel* by Jacopo Cobaert (1530–1615) and Pompeo Ferrucci (1565–1637) in the right crosspiece, and painting prepared the worshipper for the outstanding artistic creations that within the next half century would lead the way to the splendor of the Roman Baroque. A preamble for which the *Holy Trinity* on the high altar, delivered by Guido Reni around 1625, is one of its finest examples.

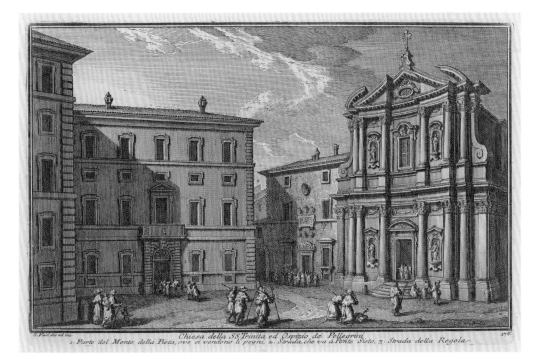

Giuseppe Vasi, *View of the Facade of the Church of the Santissima Trinità dei Pellegrini*, circa 1759, Rome, Istituto Centrale per la Grafica.

CHURCH OF THE SANTISSIMA TRINITÀ DEI PELLEGRINI
Piazza della Trinità dei Pellegrini, 1 – 00186, Rome
Monday–Saturday
open 6:45am–7:30pm
Sunday
open 8am–7:30pm
www.roma.fssp.it

Holy Trinity

1625–1626
Oil on canvas, 564 x 301 cm

This monumental altarpiece was commissioned from Guido Reni by Cardinal Ludovico Ludovisi (1595–1632), the nephew of Pope Gregory XV (1554–1623), for the purpose of decorating the church on the occasion of the Jubilee of 1625. Nonetheless, the work was delivered past the due date, and it is perhaps for this reason that Carlo Cesare Malvasia (1616–1693), the painter's biographer, insisted that Guido completed the painting in just twenty-seven days.

An imposing Crucifix is inserted in a terrestrial globe that is just hinted. Jesus Christ's pale complexion tells us that he is already dead, however his expression of suffering is still alive. His body is perpendicular with respect to the base of the painting and divides the composition into two perfectly equal parts. Above a blanket of clouds, through which we can glimpse the deep blue sky, are two pairs of angels. The first two angels, positioned lower down, are portrayed as adolescents adoring the Cross: they have large wings and elaborate gowns, and and they are praying, as their different hand gestures suggest. The other two angels are positioned slightly higher up, corresponding to the horizontal element of the Sacred Wood, and represented as naked children curiously watching the scene. At this level the clouds change color: from the whitish-gray of the terrestrial clouds to the gold of the divine ones, crowned at their extremes by the faces of the Cherubim who look toward the center of the composition where God the Father is seated on his celestial throne. He is accompanied by the Holy Spirit in the form of a dove, which is perfectly aligned with the Cross on which the lifeless body of his Son still rests. The Creator is elderly and bearded, and dressed in an elaborate and brightly colored cassock, fastened at the center by a brooch with a large ruby. A strong wind seems to move the red damask cloak on the left.

The work was definitely conceived to welcome the pilgrims in a surprising way. In increasing numbers they would travel to Rome on the occasion of devotional journeys and jubilees, often needing care and attention, which they could find there.

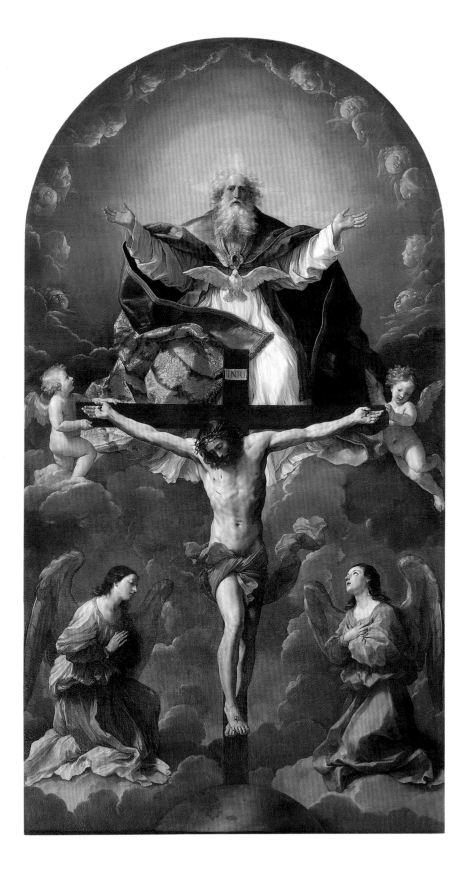

Galleria Spada

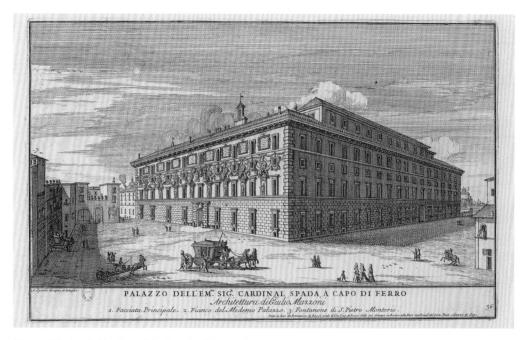

Giovanni Battista Falda, *View of the Facade of Palazzo Spada*
at Capodiferro, 1665–1739, from *Il Nuovo teatro delle fabriche et edificii*
in prospettiva di Roma moderna, Paris, Bibliothèque nationale de France.

Located in Piazza Capodiferro, halfway down the street by the same name
coming from Via dei Pettinari and headed toward Piazza Farnese, is Palazzo
Spada, featuring a marvelous facade decorated with statues and reliefs
of famous figures from Roman history, all of which were made by a group
of skilled workers coordinated by Giulio Mazzoni (1525–1618) of Piacenza.
The stucco ornamentation is the same as it was when Cardinal Girolamo
Capodiferro (1502–1559) asked the Piedmontese architect Bartolomeo
Baronino (1511–1554) to build him a residence, whose construction was
completed on the occasion of the grand Jubilee of 1550.
The eight niches set in between the windows on the first floor contain
an equal number of statues portraying Trajan, Pompey, Fabius Maximus,
Romulus, Numa, Claudius Marcellus, Caesar, and Augustus, surmounted by
cupids holding festoons, candelabra, and medallions. Beyond the entrance
is a porticoed courtyard, decorated in the same manner as the facade, with
scenes of centauromachy and hunting, and featuring spaces containing the
statues of mythological figures and deities that, in succession, form some
of the most famous couples in classical tradition. In between this decorative
order and the cornice are marine scenes and festoons.
The building was purchased in 1632 by Cardinal Bernardino Spada (1594–

1661), who immediately commissioned its restoration, hiring, among others, the famous Francesco Borromini (1599–1667). Between 1652 and 1653, the Ticino architect made one of the most fascinating examples of the Roman Baroque, the perspective tunnel. Assisted for the necessary calculations by Giovanni Maria da Bitonto (1586–?), an adviser and agent of Cardinal Spada, Borromini designed a row of columns in decreasing height, and a gradually elevating floor. The combination of these two artifices produces a powerful optical illusion, making it look like the tunnel is thirty-seven meters long, while it actually measures only eight. Inside a garden at the back is a sculpture portraying Mercury, which would appear to be life-sized, but is actually only sixty centimeters tall.

In 1927, when the family became extinct and Palazzo Spada was acquired by the Italian State, it became both the seat of the Consiglio di Stato (Council of State) and of Galleria Spada museum. Its status has not changed since then. The cultural institution, which has been part of the Direzione Musei Statali in Rome since 2019, houses a large painting gallery, most of it bequeathed by the family cardinals, Bernardino and Fabrizio (1643–1717). Worthy of note in the collection are the *Saint Cecilia* and the *Madonna and Child* by **Artemisia Gentileschi** (1593–1653), the *Death of Dido* by **Guercino** (1591–1666), a sketch for the fresco of the nave of the church of the Gesù by Giovan Battista Gaulli, called **Baciccia** (1639–1709), the *David with the Head of Goliath* by **Orazio Gentileschi** (1563–1639), the *Cain and Abel* by **Giovanni Lanfranco** (1582–1647), as well as two very interesting examples of a globe— one celestial, the other terrestrial—made by the Dutch cartographer Willem Janszoon Blaeu (1571–1638).

Works by Guido Reni

attributed, *Head of an Old Man (Slave of Ripa Grande or Seneca)*
circa 1613, oil on canvas, 66.5 x 50.5 cm

with Giacinto Campana, *Abduction of Helen*
circa 1629–1630, oil on canvas, 250 x 250 cm

GALLERIA SPADA
Piazza Capodiferro, 13 – 00186, Rome
Monday, Wednesday–Sunday (closed Tuesday)
open 8:30am–7:30pm (last entry before closing 7pm)
for advance booking: +39 06 32810
www.galleriaspada.beniculturali.it

Portrait of Cardinal Bernardino Spada

1630–1631
Oil on canvas, 222 x 147 cm

Bernardino Spada (1594–1661), a prelate of the Roman Curia who was appointed cardinal in 1626 by Pope Urban VIII Barberini (1568–1644), was papal legate in Bologna from 1627 to 1631. In this period his interest in painting intensified, as did his patronage. He soon became a patron of Guido Reni, among others, commissioning him to paint his portrait, which was delivered to him the year he returned to Rome, right before he purchased the palazzo where it is currently held along with most of his collection.

This canvas is one of the Bolognese artist's masterpieces in terms of psychological introspection. Reni was a master at revealing the nobility, intellectual finesse, and spirituality of the figures he portrayed. In this work the cardinal is seen inside his studio busy writing a letter to the pope: we know this from the heading on the sheet set down on the elegant reading stand, which reads *Beatus Padre*. Behind him is a library containing the archive where he keeps his correspondence. Although this particular piece of furniture refers to the world of the papal ritual, it also depicts the prelate's more intimate and personal world. Guido used the same realism to reproduce the prelate's surroundings, which are as institutional as they are reserved, to replicate the details of the embroidery of the snowy white surplice, the marvelous ring on his manicured left hand in the foreground, the elaborate pattern of the golden fringes on the upholstery of the armchair, the detail of the carefully groomed hair and moustache, and the red nuances pervading the composition as a whole.

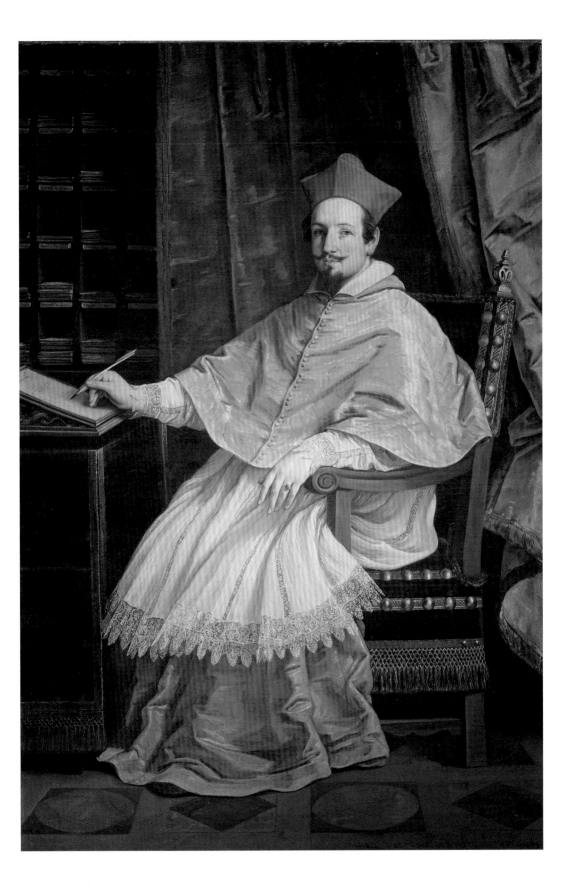

Guido Reni, *Abduction of Helen*, 1631, Paris, Musée du Louvre.

● *THE ABDUCTION OF HELEN:* GUIDO RENI FROM ROME TO EUROPE

Very few paintings in the history of painting have, from the moment they were created, enjoyed as much success as Guido Reni's celebrated *Abduction of Helen*, now at the Musée du Louvre in Paris. The large-scale canvas immediately became the subject of detailed descriptions, high praise, and countless poetic compositions exalting its measured composition, limpid palette, and classical forms outside of Italy as well. Success that continued to grow because of the complex events surrounding the sale, delivery, and final destination that liken the work's history to the equally complex one of the lost *Bacchus and Ariadne* (see pp. 62–63). The *Abduction of Helen* was commissioned from Guido Reni in 1626 by the King of Spain Philip IV Habsburg (1605–1665) through Íñigo Vélez de Guevara Count of Oñate (1597–1658), the Iberian ambassador to the Papal State between 1626 and 1628. The importance of the patron and the extraordinary opportunity for diplomacy that the Spanish request offered the Barberini papacy encouraged the cardinal nephew Francesco Barberini (1597–1679) to entrust the papal legate in Bologna, Cardinal Bernardino Spada (1594–1661), with the task of keeping an eye on the making of the work in the artist's studio. Although the canvas had already been finished between 1628 and 1629 and sent to Rome in preparation for its journey to Spain, it became the bone of contention between the Spanish monarchy, on the one hand, and the cardinal nephew with Reni himself, on the other. The painter's decision not to agree on a price for the work (for the purpose of encouraging the generosity of the Spanish sovereign), the small fee suggested by the newly elected ambassador Cardinal Borgia, as well as an iconography that did not completely adhere to what the Iberian government had countenanced led to a fierce dispute that ended with the termination of the agreement. In short, the sale failed to go through. Neither the failed agreement nor the diplomatic incident were enough to stop Cardinal Spada, however, a great supporter of the Bolognese painter as well as his patron (see pp. 78–79). The cardinal volunteered to act as an intermediary between the Queen of France Marie de' Medici (1575–1642) and Guido Reni, seeking first to convince the artist to leave for the French court, and then for the queen to acquire the already famous *Abduction of Helen* and encourage the Bolognese artist to move to France. Nevertheless,

the lengthy negotiations led nowhere because of the painter's reluctance to leave Bologna, his mother's long-term illness, the plague, and the adventurous end of the reign of Marie de Medici, who fell from favor after Cardinal Richelieu (1585–1642) staged a coup against her. Bernardino Spada had to wait until 1643 to sell the painting to the Marquis La Vrillière (1599–1681), who turned Reni's canvas into the centerpiece of his Paris gallery where it remained until the French Revolution. Cardinal Spada would never have allowed the famous painting to leave without getting at least one faithful copy of it, however. As early as May 2, 1631, the cardinal sent Reni the generous amount of 200 *ducati* for the notable portrait that is still at the Galleria Spada today, and for a "Helen perfected" by the same artist. The *Helen* that is cited can almost certainly be identified as the *bella copia* (good copy) of the *Abduction*, which, as the biographer Malvasia recalled, the cardinal managed to have made directly in the studio of the "Divin Guido" by the hand of Giacinto Campana (circa 1600–circa1650), one of the artist's best pupils. This way "the memory at least and the example of such a wonderful story should remain in Italy." The copy, which for a long time was in part believed to be a work by Reni himself, became the core work of the Galleria Spada, juxtaposed with the original work and its new French location. Both canvases were the subject of unrelenting veneration, transforming Reni into an absolute superstar in Europe, capable of igniting clashes between the ambassadors, cardinals, popes, and kings who wanted one of his works so that they could exhibit it as one of the best diplomatic representatives of Italian painting, synonymous with elegance and diplomatic power. A great story of European collecting that began in the Salon Nuevo of the Alcázar of Madrid, for which the canvas was conceived but where it never actually arrived, led to Palazzo Barberini in Rome, where the work was displayed during the negotiations with the Spanish ambassadors, and ended at the prestigious Galerie La Vrillière in the Paris of Louis XIV. Three symbolic locations in a Europe that was increasingly becoming interconnected in terms of taste and the commissions from an artist who, while he was still alive, had come to represent the century during which Italian painting was a political tool and served as an international representative of an unrivaled artistic reality.

Church of Santa Maria in Vallicella
or Chiesa Nuova

Giovanni Battista Falda, *View of Piazza della Chiesa Nuova*, 1665–1739, from
Il Nuovo teatro delle fabriche et edificii in prospettiva di Roma moderna, Paris,
Bibliothèque nationale de France.

On July 15, 1575, when Gregory XIII (1502–1585) formally recognized the
Congregation of the Oratory founded in 1551 by Philip Neri (1515–1595), it
was the beginning of a second great life for the ancient church of Santa
Maria in Vallicella. In addition to recognizing it from an institutional point
of view, the pope donated to the community of regular priests who had
gathered around Neri the ancient church that had been recorded from the
thirteenth century and was called Vallicella. The church had been built in
a valley (hence the name) that may have at one time corresponded to an
underground sanctuary dedicated to the worship of infernal deities. From
the very start the ancient church with three naves proved to be unsuited to
the growing success of the congregation, and to the streams of pilgrims who
were welcomed by the young religious institute. It was therefore decided to
rebuild the church, literally creating a new church, or "Chiesa nuova." The
project was commissioned from Matteo di Città di Castello (1530–post 1597)
in 1575, who planned a church with a single nave and four chapels per side
modeled after the recently built church of the Gesù. Perhaps due to a series
of problems related to static, or the fact that the new building was too similar
to the Jesuit model, led to Martino Longhi the Elder (1534–1591) taking
over the project from 1586 to 1590. The new architect added two more side

chapels and transformed the eight that had previously been built into two narrow naves, reconstructing the previous spaces by adding a semicircular space. The church was even given a new apse, transept, and dome, and it was consecrated in 1599, a few years after the facade was finished. The very elaborate interior decoration began filling the church from the early seventeenth century, keeping the congregation and Roman aristocracy busy for about a century. **Pietro da Cortona** (1597–1669) made the stuccowork for the ceiling, as well as frescoes portraying the *Miracle of the Virgin during the Construction of the Church* in the principal nave (1664–1665), the *Prophets* in the pendentives (1659–1660), the *Triumph of the Trinity* in the cupola (1647–1651) and the *Assumption of the Virgin* in the apsidal conch (1655–1660). Placed above the high altar was the much-revered fourteenth-century image of the *Madonna della Vallicella*, which had been discovered in the church in 1574. This was added to the Roman masterpiece by **Pieter Paul Rubens** (1577–1640): a large-scale oil-on-slate altarpiece (1606–1608) surrounding the detached Marian fresco with concentric circles of adoring angels. In addition to the panel and two large paintings of *Saints Domitilla, Nereus, Achilleus, Gregory the Great, Maurus and Papias* placed to either side of the presbytery, the Flemish artist also painted a replica of the miraculous image on a copper sheet, to be used as a cover for the precious effigy. A rope mechanism was used when the cover needed to be removed. The decorative campaign was not limited to the church, but it also included works such as the *Saint Philip and an Angel* by **Alessandro Algardi** (1598–1654) in the sacristy, and the decorated ceiling by **Pietro da Cortona** in the same room, not to mention the remarkable number of works present in the rooms of the Santuario Terreno and of the Santuario Superiore, ancient spaces inhabited by the Saint that upon his death became places of worship and devotion.

CHURCH OF SANTA MARIA IN VALLICELLA OR CHIESA NUOVA
Piazza della Chiesa Nuova – 00186, Roma
Monday–Saturday
open 6:45am–noon; 5pm–7:45pm
Sunday
open 8am–noon; 5pm–8pm
by appointment visitors can also see San Filippo Neri's Rooms, which house an interesting collection of art and devotional objects. For information and advance booking send email to mail.acor@gmail.com
www.vallicella.org

The Vision of Saint Philip Neri

1614,
Oil on canvas, 180 x 110 cm

Kneeling before a non-script background from which the faces of several small, chubby cherubs emerge, God's jester, born Philip Neri (1515–1595), appears before the eyes of the faithful. The much-venerated saint gazes upwards toward the Virgin. In total adoration of the miraculous Marian apparition, he widens his arms and is struck by a ray of light. His liturgical attire, an elegant purple- and violet-hued chasuble with gold surface decorations attracts the viewer's eye, contrary to what one might imagine making the composition even more realistic. Here Reni stages what happened during the religious celebrations led by the saint, when the "second apostle of Rome," immersed in prayer, entered into the ascetic contemplation of miraculous apparitions. Once again, the painter consigns to history a highly successful composition that in the decades after its making would be copied, readapted, and varyingly assembled numerous times, becoming the iconographic prototype of the saint's portrayal throughout the seventeenth century. The canvas was commissioned by the Congregation of the Oratory for the saint's chapel in the Vallicellian church. The painter was paid for his work on October 4, 1614, and it was probably completed in the early months of the following year, 1615, as proven by Luca Ciamberlano's (1580–1641) engraving of the same composition. The critics have also suggested that the painter added the figure of the Virgin and Child, as well as that of the angels at a later date, having noted the absence of a visual connection between the saint and the apparition. This element, albeit clearly visible in the image, still would not justify a later intervention by the artist. The absence of this visual connection is reproduced in almost the exact same way in an ancient copy of the work, perhaps attributable to Reni himself, preserved in the Neapolitan church of the Girolamini. There are numerous other versions scattered across Italy as well as in the church that first housed the painting. The work was moved from the altar to the private apartment of the saint on the upper floor adjacent to the church, and in 1777 it was replaced with a copy in mosaic.

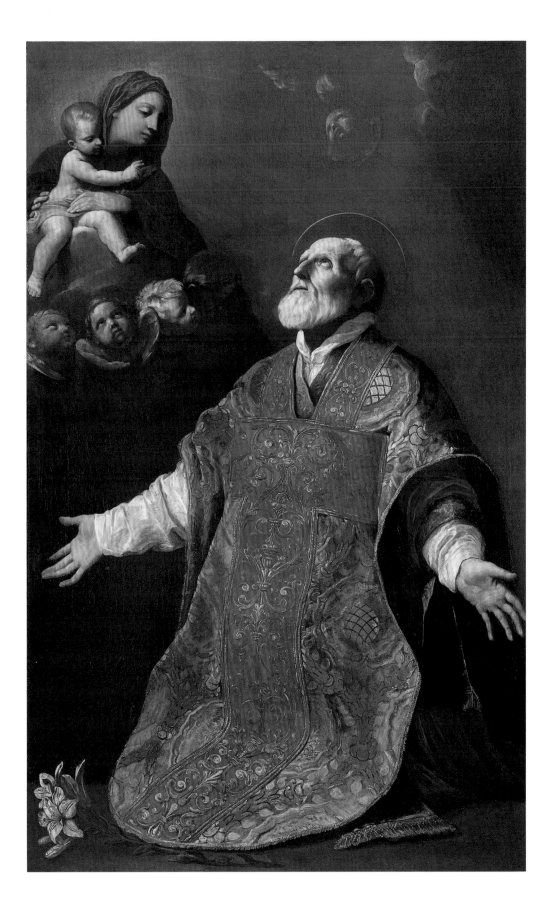

Museo di Roma – Palazzo Braschi

Erected in the trapezoid-shaped block between Piazza di Pasquino, Piazza San Pantaleo, and Piazza Navona, the current edifice was built from 1792 in the area where Palazzo Orsini had previously stood. The original building had been erected at the behest of the Roman prefect Francesco Orsini (1455–1503), and enlarged by Cardinal Oliviero Carafa (1430–1511) in 1501. In 1516 it was completed with a tower to a design by Antonio da Sangallo the Younger (1484–1546).

Upon the request of his nephew Luigi Braschi-Onesti (1745–1816), Pope Pius VI Braschi (1717–1799) had the old residence demolished in 1791 and commissioned the new building from the Imola architect Cosimo Morelli (1745–1816). The work was interrupted several times, and it was finally finished in 1811. With the Unification of Italy, the building became property of the Italian State and was used first as the headquarters of the Ministry of the Interior, then of the Federazione Fascista dell'Urbe, and, finally, from 1952, it became seat of the Museo di Roma. The museum hosts a wealth of interesting paintings, sculptures, and objects that can help to reconstruct the most significant historical-cultural aspects of Rome.

Many of the paintings in Palazzo Braschi were produced over the course of the seventeenth century. The most interesting ones represent scenes from everyday life in the papal city, especially the ones portraying celebratory images. These include paintings on the subject of the *Tournament in the Courtyard of the Belvedere* (circa 1610), which took place on March 5, 1565 for the marriage of Annibale Altemps and Ortensia Borromeo, originally in the Mattei collection, by **Filippo Gagliardi** (1606/1608–1659) and Vincent Leckerbetien, called **Manciola** (circa 1600–1650), the *Bentvueghels in a Roman Tavern* (1626–1628) by **Roeland van Laer** (1598–1635), the *Saracen Joust in Piazza Navona on February 25, 1634* (circa 1634) by **Andrea Sacchi** (1599–1661) and the *Tree on the Piazza del Campidiglio on the Occasion of the May Tree* (circa 1634) by **Agostino Tassi** (circa 1580–1644).

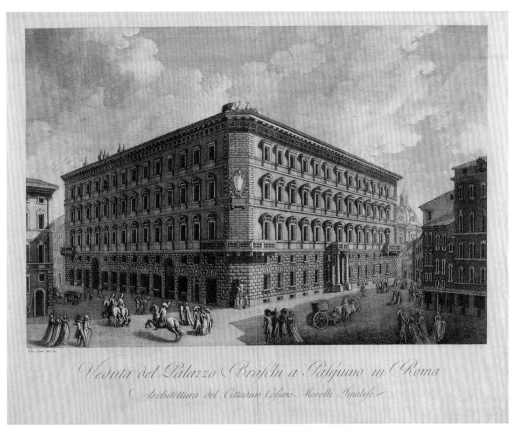

Veduta del Palazzo Braschi a Pasquino in Roma
Architettura del Cittadino Cosimo Moretti Imolese

Ciro Santi, *Palazzo Braschi Viewed from Piazza Pasquino*,
circa 1755, Rome, Museo di Roma, Palazzo Braschi.

 MUSEO DI ROMA – PALAZZO BRASCHI
Piazza di San Pantaleo, 10 – 00186, Rome
Piazza Navona, 2 – 00186, Rome
Tuesday–Sunday (closed Monday)
open 10am–19pm (last entry before closing 6pm)
www.museodiroma.it

Processional Banner of Saint Francis

1611–1612
Oil on canvas painted on both sides, 217 x 152 cm

One of the most important religious paintings preserved at the Museo di Roma is the processional banner for the Confraternity of the Stigmata depicting *Saint Francis Receiving the Stigmata* and *Saint Francis and the Brethren of the Confraternity of the Stigmata*. Probably originally made for the confraternity itself in nearby Campagnano Romano, this unusual devotional object was painted by Guido Reni, with the collaboration of his workshop, between 1610 and 1612. Before becoming part of the Museo di Roma collections, around 1629 the banner was owned by Clemente Boncompagni Corcos, who donated it to the Confraternity in 1657. It was later sold to the Chigi family in 1661. The family kept it in their collection and finally sold it to the City of Rome, which currently still owns it.

Portrayed on the canvas, which is painted on either side, is the episode of Saint Francis receiving the stigmata according to the description of the event in the *Legenda Maior* (XIII, 3) by Bonaventura da Bagnoregio (circa 1217/1221–1274). Reni portrays Francis, who is accompanied by Brother Leo, as he widens his arms before the appearance of the Angel that is the source of the light that leaves the signs of the Passion of Christ on his body, piercing his hands and rib cage. Pictured on the other side of the banner is the saint standing amidst the members of a confraternity, probably the very one that was meant to carry the banner in a procession. With his left hand he bears the cross, with his right he points to Heaven.

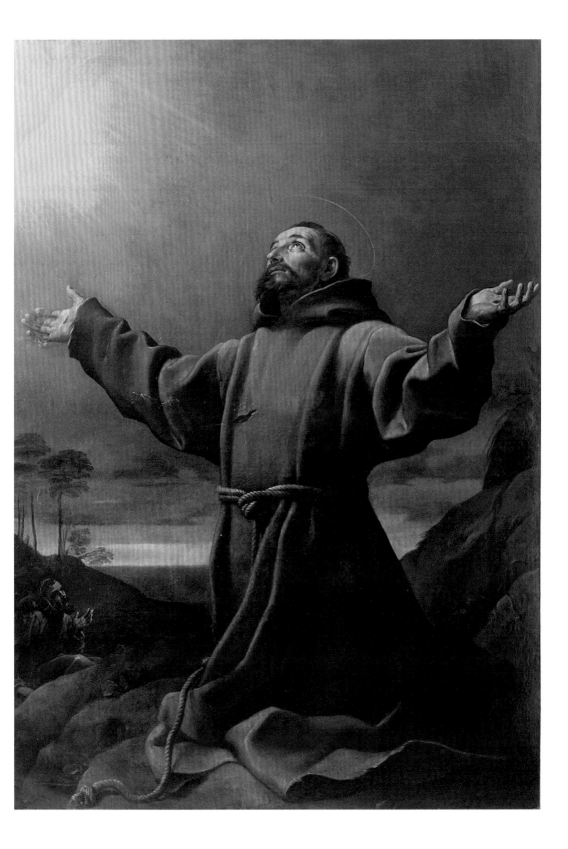

Church of San Luigi dei Francesi

Flanked by the palazzo of the same name between the piazza and the perpendicular Via Santa Giovanna d'Arco, San Luigi dei Francesi has been the French national church of France in Rome since 1518, the year when its construction began at the behest of Cardinal Giulio de' Medici, the future Pope Clement VII (1478–1534). Its construction was completed in 1589 by Domenico Fontana (1543–1608) to a design by Giacomo Della Porta (1532–1602).

The interior is divided into three naves and is characterized by rich marble and stucco decorations made between 1756 and 1764 by Antoine Dérizet (1685–1768); moreover, almost all ten of its chapels hold some of the most precious seventeenth-century paintings in Rome. The most famous of these chapels is no doubt the **Contarelli Chapel**, the fifth from the left, where the frescoes by Giuseppe Cesari, better known as **Cavalier d'Arpino** (1568–1640) are completed by canvases depicting the *Calling of Saint Matthew*, *Saint Matthew and the Angel,* and the *Martyrdom of Saint Matthew* (1599–1600) by his most famous pupil engaged in his first public works, Michelangelo Merisi da **Caravaggio** (1571–1610). Along the same nave, the fourth chapel hosts paintings by **Charles Mellin** (circa 1597–1649) and **Giovanni Baglione** (circa 1573–1643). The altarpiece (1664) in the chapel dedicated to Louis IX is a painting by the Roman *architettrice* **Plautilla Bricci** (1616–1705). In the opposite nave, the second chapel is decorated with one of the fresco masterpieces by **Domenichino** (1581–1641), the *Martyrdom of Saint Cecilia* (1616–1617), completed in the vault by the glory of the martyr and on the altar by a copy made by Guido Reni of Raphael's painting for the church of San Giovanni in Monte in Bologna, portraying the *Ecstasy* of the saint.

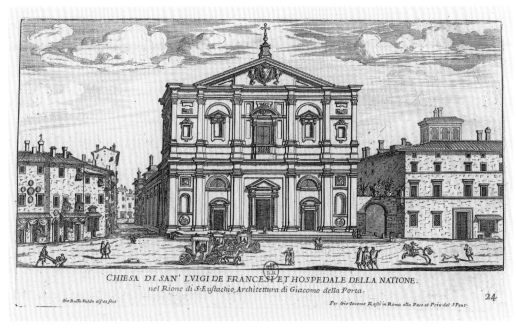

Giovanni Battista Falda, *Church of San Luigi dei Francesi*, 1665–1739,
from *Il Nuovo teatro delle fabriche et edificii in prospettiva di Roma moderna*,
Paris, Bibliothèque nationale de France.

CHURCH OF SAN LUIGI DEI FRANCESI
Piazza di S. Luigi de' Francesi, 5 – 00186, Rome
Monday–Friday
open 9:30am–12:45pm; 2:30pm–6:30pm
Saturday
9:30am–12:15pm; 2:30pm–6:45pm
Sunday
11:30am–12:45pm; 2:30pm–6:45pm
www. saintlouis-rome.net

Copy after the *Ecstasy of Saint Cecilia* by Raphael

1600
Oil on canvas, 215 x 137 cm

According to Giovanni Pietro Bellori (1613–1696), a major seventeenth-century biographer, when the young Reni was still a pupil in the school of the Carracci in Bologna, he repeatedly copied Raphael's famous altarpiece depicting the *Ecstasy of Saint Cecilia with Saints Paul, John the Evangelist, Augustine, and Mary Magdalene*. The painting that Raphael made in Rome in 1518 and was then brought to Bologna to be placed in the church of San Giovanni in Monte in the family chapel of Elena Duglioli dall'Olio (1472–1520) became a point of unescapable comparison for Guido.

The copies were not only a tool that the painter could study, they were also the subject of commissions outside of Bologna, attested to by various documentary records. Around 1618, the Sienese art collector, papal physician, and author of *Considerazioni sulla pittura* Giulio Mancini (1559–1630) recalled seeing a copy of Raphael's painting in the Basilica of Santa Cecilia in Trastevere. The work, which had already been mentioned in 1609 in an inventory of the Sfondrati family, could have been commissioned, perhaps through the papal legate in Bologna, by Cardinal Paolo Emilio Sfondrati (1560–1618) himself. In those years the cardinal was engaged in restoring the cult of the saint and the modernization of the church dedicated to her, of which he was the titular cardinal (see pp. 112–113). The painting, which remained in the family collection until the late seventeenth century, is paired with another copy, recorded for the first time by the painter Gaspare Celio (1571–1640) in the church of San Luigi dei Francesi in the same years as the previous version in the Trastevere. Although he did not publish his *Delli nomi dell'artefici delle pitture, che sono in alcune chiese, facciate,* *e palazzi di Roma* until 1638, Celio cited the work without attributing it to Reni as early as 1620. Bellori, instead, attributed the painting in San Luigi dei Francesi to the Bolognese artist in 1672, believing it to be the one historically recorded in the basilica beyond the Tiber. It is likely that Guido Reni made several copies of Raphael's painting, which is currently at the Pinacoteca Nazionale in Bologna. The discovery of a new copy of Raphael's painting in the collections of the National Gallery of Ireland in Dublin (inv. NGI.70) suggests that the Irish version is the one that was made in Bologna for Sfondrati to be placed in the Basilica of Santa Cecilia, while this one in the national church of France is a different version, painted by the artist when he was already in Rome, perhaps for Daniel (?–1613) and Pierre Polet, the patrons of the chapel where it is still located today. The dark hues with respect to the Dublin version and to Raphael's original work have encouraged the critics to suggest that the painter was experimenting. The idea has been put forward that after Reni arrived in Rome and compared his work with the results achieved by Caravaggio (1571–1610), he was so impressed he even altered his activity as a copyist. The work is the only one that the Polets, uncle and nephew, managed to obtain from Guido, whom they had sought out not only for the altarpiece but for the entire fresco decoration of the chapel with the life of Cecilia. According to Carlo Cesare Malvasia (1616–1693), the painter's biographer, faced with the artist's refusal, the French patrons were forced to make their requests to the more well-inclined and modest Domenichino (1581–1641), a native of Bologna like Reni, who decorated the entire liturgical space, except for the altar, by around 1615.

Galleria Doria Pamphilj

Giovanni Battista Falda, *View of Palazzo Doria Pamphilj on Piazza del Collegio Romano*, 1665–1739, from *Il Nuovo teatro delle fabriche et edificii in prospettiva di Roma moderna*, Paris, Bibliothèque nationale de France.

Very few places like the Palazzo and Galleria Doria Pamphilj manage to tell their history so clearly, in this case made up of the merging of the estates, acquisitions, and patronage of noble Roman families, among other things. The intricate events of the complex, which currently occupies a large block in the city's historical quarter, began in the early sixteenth century and continued until the second half of the nineteenth century. The first Renaissance building, of which the large courtyard is perhaps the only evidence that still exists, was the residence of Cardinal Fazio Santoro (1447–1510) until it was sold to the Della Rovere. After being sold to Pietro Aldobrandini (1571–1621), in 1638 the original palazzo became a part of the rich dowry of Olimpia Aldobrandini junior (1623–1681), the prelate's niece and sole heir, who, soon after her husband Paolo Borghese (1624–1646) died, was remarried to Camillo Pamphilj (1622–1666) in 1647. Her new consort, who had given up a cardinalship for her, dedicated himself untiringly to enlarging the palazzo to a design by the architect Antonio Dal Grande (1607–1679), with the partial demolition of several nearby sixteenth-century buildings and the realization between 1659 and 1663 of new facades overlooking Via Lata and

Via della Gatta. It was during those years that the already vast Aldobrandini collection, which had come with Olimpia's dowry and contained several Ferrarese and Venetian Renaissance masterpieces, came to include several emblematic works, such as the *Rest on the Flight into Egypt* by **Caravaggio** (1571–1610) and the *Portrait of Innocent X* by **Velázquez** (1599–1660). When Camillo passed away, the large building site, as well as the expansion and rearrangement of the collection, were taken over by his widow and children, who, depending on whether they belonged to one branch of the family or another, would inhabit and alter the spaces and the decorations of a portion or all of the complex. An example of this is the intervention by the architecy Gabriele Valvassori (1683–1761), who worked on a generalized modernization of the entire building between 1731 and 1734, especially redefining the long facade overlooking the Corso. An articulate story which became even more complicated when the Roman line of the family was extinguished and the complex, along with everything inside it, joined the already wealthy estate of the Genoese Doria family. In 1763 the complicated dynastic relations would eventually lead to the merging of the two families' heraldry, and the building's current name: Palazzo Doria Pamphilj. The final works were carried out by Andrea Busiri Vici (1818–1911), beginning in 1846 and ending in 1871, taking place alongside a new design for the rich collection. Today the gallery and the palazzo, one of the few in which the original family still lives, boast an outstanding collection of objects and artworks: from *Erminia Finding the Wounded Tancred* by **Guercino** (1591–1666), and *Penitent Saint Jerome* by **Domenico Beccafumi** (1486–1551), to the *Saint John the Baptist* by **Caravaggio**, and the *Madonna and Child* by **Parmigianino** (1503–1540). A remarkable collection that ranges from Renaissance masterpieces by **Giovanni Bellini** (circa 1427 or 1430–1516) and **Garofalo** (1476 or 1481–1559) to **Mattia Preti** (1613–1699) and **Alessandro Algardi** (1598–1654), accompanying the visitor through the many layers of history and refined collecting activity of the Roman aristocracy.

GALLERIA DORIA PAMPHILJ
Via del Corso, 305 – 00186, Rome
Monday–Thursday
open 10am–7pm (last entry before closing 5:30pm)
Friday–Sunday
open 10am–8pm (last entry before closing 6:30pm)
www.doriapamphilj.it/roma

The Combat of Cupids and Baccarini

1627–1628
Oil on canvas, 120 x 152 cm

The painting represents a battle between three pairs of putti, differentiated by specific features. There are cupids, who are the winged followers of the god Cupid, who are also characterized by their light, lunar complexion while the wingless and darker putti are baccarini, the small disciples of Bacchus, the god of wine and inebriation. Confirming their identities are the objects scattered throughout the composition: here and there in the foreground we notice a quiver and several arrows, while the background is filled with several containers of wine and a pergola covered with grapevines. The mythological battle was a metaphor for contemporary society with the constant discord between the fair-skinned nobility, and the people, whose olive complexion bears witness to their toil in the open air, especially in the fields. This interpretation was made possible thanks to some early descriptions of

the work as a "Lotta di putti plebei contro putti nobili" (Combat between Plebeian Putti and Noble Putti).
The painting is linked to a particular circumstance in Guido's life as recounted by Carlo Cesare Malvasia (1616–1693) in his biography of the painter. It seems that after a fight with the Spanish Ambassador, Reni ended up in prison, from which he was released thanks to the intervention of the Marquis Ludovico Facchinetti (1590–1655) of Bologna. To express his gratitude the painter gave him the painting that the antique literary sources describe as the "famosa lotta di Amoretti e Baccarini."
On the basis of this circumstance, the painting can therefore be dated to 1627. It joined the collection of Giovan Battista Pamphilj (1648–1709), Pope Innocent X's nephew, in 1671, when he married Violante Facchinetti (1649–1716), Ludovico's daughter, as part of her dowry.

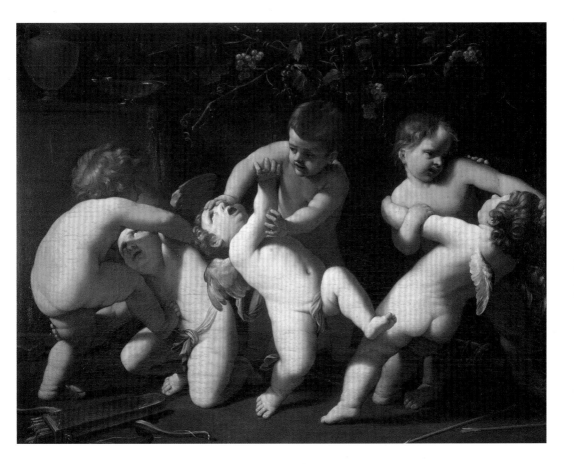

Church of San Lorenzo in Lucina

The church devoted to the deacon Lawrence, who became a martyr in 258 during the persecutions of Emperor Valerian, is one of the oldest places of worship in Rome, as demonstrated by the "titulus Lucinae" attested to as early as 366. The original religious building stood on the area that was occupied by the residence of the Roman matron Lucina. It was later transformed into a public place of worship during the reign of Sixtus III (? – 440). After that it underwent major restoration work under Paschal II (1053/1055–1118). Its original appearance changed radically in the mid-seventeenth century when the Clerics Regular Minor, who had become the licensees of the church under Paul V (1552–1621) in 1606, commissioned Cosimo Fanzago (1591–1678) to remodel the complex. Fanzago, a Neapolitan by adoption, eliminated the two small side naves, turning the space into gentilitial chapels, where, in the following years, artists active in Rome in the second half of the seventeenth century intervened. The great scenic space conceived by Fanzago, who chose the high altar designed by Giuseppe Sardi (1680–1771) and the famous *Crucifixion* by Guido Reni as a visual fulcrum, can only in part be admired today due to the nineteenth-century restoration work by Andrea Busiri Vici (1818–1911), who removed most of the Baroque decorations. Only the side chapels survived Vici's drastic interventions, visible in the *Saint Charles Borromeo* (second chapel to the left) by **Carlo Saraceni** (1585–1625) and the Fonseca Chapel (the fourth to the right) that still features the attractive cupola with stucco angels and marble busts of the deceased family members; that of *Gabriele Fonseca*, made by **Bernini** (1598–1680) between 1668 and 1673, especially stands out. The fifth chapel to the left as well, owned by the Alaleona family, still hosts one of the most beautiful decorations of Baroque Rome, the *Death of Saint Hyacintha Marescotti* by Marco Benefial (1684–1764); also visible are the outstanding side canvases (*The Taking of the Habit of Saint Francis* and the *Temptation of Saint Francis*) painted along with the frescoes on the ceiling around 1624 by **Simon Vouet** (1590–1649).

Giuseppe Vasi, *Piazza San Lorenzo in Lucina*, 1747,
Rome, Istituto Centrale per la Grafica.

 CHURCH OF SAN LORENZO IN LUCINA
Piazza di San Lorenzo in Lucina, 6 – 00186, Rome
open every day 8am–noon; 4:30pm–7:30pm

The Crucifixion

Circa 1630
Oil on canvas, 340 x 220 cm

The majestic high altar of the church designed and made by the architect Carlo Rainaldi (1611–1691) is crowned by the wonderful canvas by Guido Reni, which was placed here in 1669 after it was bequeathed.

The scene of the extreme sacrifice of Jesus Christ is situated at the heart of an intersection of lights, which dramatically burst onto the scene ripping through the darkness and illuminating the landscape in the background. In the hillside, where small groups of people are visible, the viewer glimpses a city surrounded by a solid encircling wall, at the center of which is an imposing sacred building: it is Jerusalem and its awe-inspiring Temple. Just outside the city, Mount Calvary—or Golgotha—is hinted at in the composition, and can be recognized especially by the position of a skull at the foot of a large Cross with the body of Christ.

Jesus is not dead yet: on his rib cage the wound made by Longinus' spear is not yet visible. He gazes upwards and his lips are parted, in perfect accordance with what is narrated in the Gospel when Jesus addresses the Father with the words: "My God, My God, Why hast thou forsaken me?"

The significant adherence to the sacred text underscores the strong devotional nature of the work: the great painting was made around 1638 for the Bolognese Marquise Cristina Duglioli (?–1669), who arrived in Rome with her complete collection of paintings after her husband, Senator Andrea Angelelli (?–1643), was murdered in Bologna. Her residence in Rome, located in a small palazzo on the corner between Via dei Condotti and Via del Corso, housed some of the most interesting masterpieces by major seventeenth-century artists, including paintings by Guercino (1591–1666) and Mattia Preti (1613–1699).

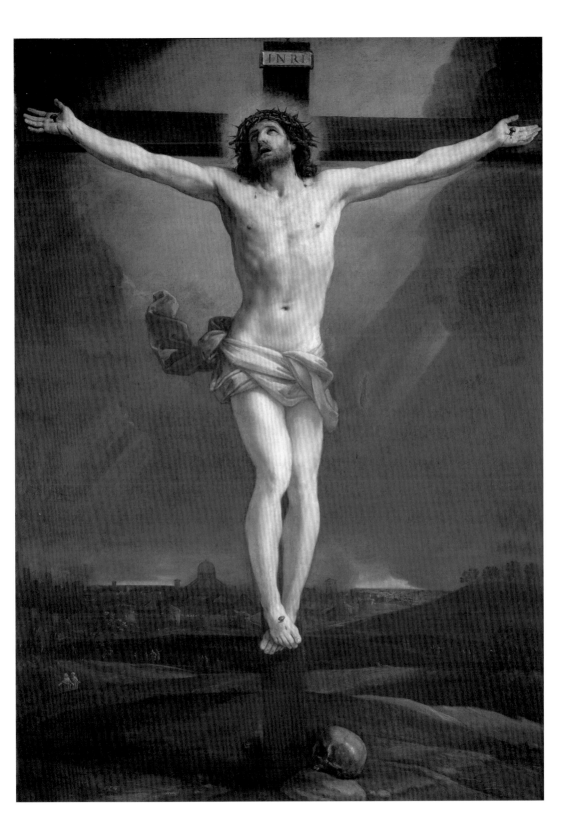

Pinacoteca Capitolina

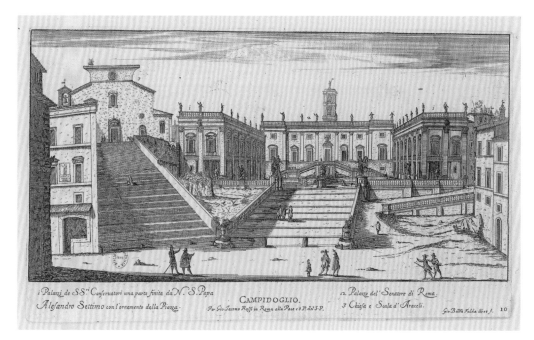

Giovanni Battista Falda, *View of the Capitoline Hill*, 1665–1739,
from *Il Nuovo teatro delle fabriche et edificii in prospettiva di Roma moderna*,
Paris, Bibliothèque nationale de France.

In 1748, just fourteen years after the founding of the Museo Capitolino and its installment in the rooms of the Palazzo Nuovo at the Campidoglio, the museum that was managed at the time by the Camerlengato and by the Palazzo Apostolico was enriched with the acquisition of over one hundred eighty paintings from the Sacchetti Collection. This arrival of numerous paintings for the collections, thanks to the involvement of Benedict XIV (1675–1758) and his Secretary of State Cardinal Silvio Valenti Gonzaga (1690–1756), was the founding act of the so-called "Pinacoteca Capitolina," the picture gallery now on the second floor of the Palazzo dei Conservatori and an integral part of the Musei Capitolini. In 1750 another one hundred and twenty six paintings were added to the collection, coming from the Collezione Pio di Savoia (1717–1776). These had been withheld by the pope following the request of Giberto Pio di Savoia for permission to export the collection abroad. Thanks to the albeit partial acquisition of the two collections, the pope managed to rescue from dispersal two of the city's most prestigious collections of paintings, assembled between the sixteenth and seventeenth centuries, and capable of easily demonstrating the great collecting tradition of Baroque Rome, as well as the Italian and European artistic output from the Middle Ages to the eighteenth century. The collections continued to grow in the following centuries with

acquisitions and donations (especially worthy of note is that of the Roman Count Francesco Cini in 1881), transforming the original group of works in the Pinacoteca Capitolina into a vast and highly prestigious collection. Most notable are priceless works like *The Holy Family* by **Dosso Dossi** (circa 1468–1542), the *Baptism of Jesus Christ* by the young **Titian** (1488/1490–1576), the large group of later works by Guido Reni (*Saint Sebastian*, *Anima Beata, Cleopatra, Lucrezia,* and the *Woman with Crown*), the *Burial of Saint Petronilla* by **Guercino** (1591–1666), and *The Fortune Teller* and *Saint John the Baptist* by **Caravaggio** (1571–1610).

Works by Guido Reni

 Saint Sebastian
circa 1615, oil on canvas, 128 x 98 cm

Saint Jerome
circa 1633–1634, oil on canvas, 63 x 53 cm

Penitent Magdalene
1635–1640, oil on canvas, 77.5 x 59 cm

Polyphemus
1639–1640, oil on canvas, 52 x 63 cm

 Anima Beata or Guardian Angel
1640–1642, oil on canvas, 252 x 153 cm

Sketch for the Anima Beata or Angelo Custode
1640–1642, oil on canvas, 57 x 45 cm

Lucrezia
circa 1640–1642, oil on canvas, 91 x 73 cm

Cleopatra
circa 1640–1642, oil on canvas, 91 x 73 cm

Woman with Crown
circa 1640–1642, oil on canvas, 91.5 x 73 cm

The Child Jesus with Saint John the Baptist
circa 1640–1642, oil on canvas, 86.5 x 69 cm

Woman with Vase
circa 1640–1642, oil on canvas, 75 x 63 cm

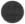 MUSEI CAPITOLINI – PINACOTECA CAPITOLINA
Piazza del Campidoglio, 1 – 00186, Rome
Monday–Sunday
9:30am–7:30pm (last entry before closing 6:30pm)
www.museicapitolini.org

Saint Sebastian

Circa 1615
Oil on canvas, 128 x 98 cm

This painting was part of the collection of Cardinal Pio di Savoia and, from the very first documents of 1641 where it is mentioned, it is firmly attributed to the hand of Guido Reni. A stamp on the back of the painting allows us to identify the previous provenance of the work, which had belonged to Cardinal Francesco Maria del Monte (1549–1626), and was sold in 1628 together with two paintings by Caravaggio—*The Fortune Teller* and *Saint John the Baptist*—now in the same museum.
The subject was reproduced several times by Reni who used the same composition, albeit slightly varied, in at least two other cases now at the Galleria di Palazzo Rosso in Genoa and at the Rhode Island School of Design Museum of Art in Providence, Rhode Island. The distinguishing feature in these paintings is the combination of the religiosity expressed by the saint, typical of Guido's devotional painting after his Roman sojourn, ending in 1614, and the idealization of everydayness and real elements, visible here in the details from the natural world.

Sebastian, a military martyr who lived at the time of Diocletian (214–313) and who was worshipped by Western and Eastern Christians, is represented at the very start of his agony, which involves his being pierced by arrows: only three arrows have so far struck the athletic, statuary, and vigorous body of the man, who shows no signs of suffering, but rather a sense of profound devotion, visible in his bright eyes gazing heavenward, searching for the true comfort of God. The young man's wrists are tied to a tree, and he is wearing simple white drapery that serves as a loincloth, an element that brings him close to Jesus Christ, as it is the only piece of clothing covering the body of Christ at the moment of his ultimate sacrifice. Small droplets of blood ooze from the wounds left by the arrows. In the background, on the right, several small figures described with quick and light brushwork appear immersed in a landscape of thick luxuriant vegetation against a marvelous sky featuring the colors of the sunset.

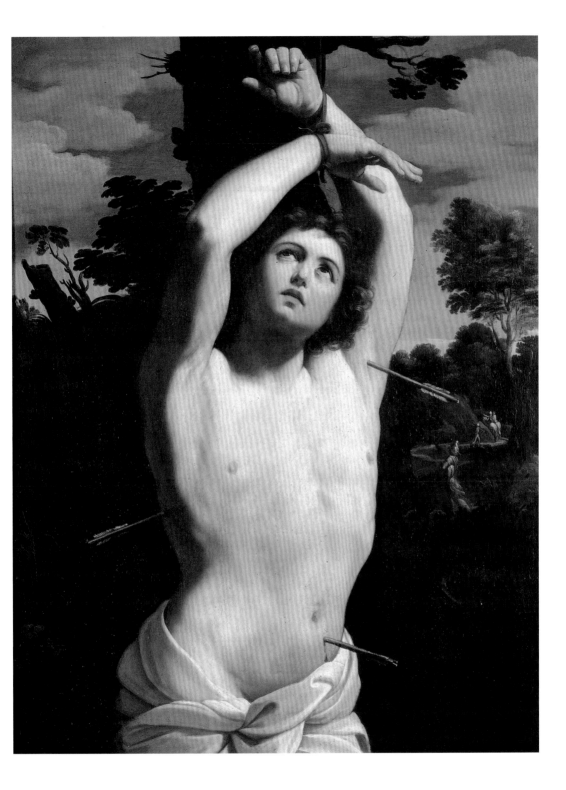

Anima Beata or Guardian Angel

1640–1642
Oil on canvas, 252 x 153 cm

This painting, which arrived in the Pinacoteca Capitolina in 1748 through the bequest of the collection of Alessandro Sacchetti (1589–1648), the brother of Cardinal Giulio (1587–1633), was included among the objects that Guido Reni kept in his Bolognese studio, as recorded in the notary document held in the State Archives in Bologna.

The subject of the work was uncertain from the moment it was rediscovered in Reni's *atelier*: in the Bolognese document, it is described as "a painting with a divine Love, said to have been owned by Sig. Alessandro Sacchetti," while in the 1688 inventory of the Roman family it is listed as "an angel, that is to say, a soul rising to heaven."

The composition features a nude young man, his wings unfurled and the intimate parts of his adolescent-like body barely covered by red and pink drapery. His feet lightly touch a globe, almost as if he were about to take flight.

Around this figure looking up to the heavens a blanket of grayish clouds floats upwards to reach a luminous opening surrounded by angelic faces. Because of the gesture of the outstretched arms with hands turned toward the bright celestial vision in the upper part of the composition, some scholars have identified the figure as a rational and blessed soul who repents for its misdemeanours on earth, and rises up to the sky through the grace that God gives to those who pray. The physical nature of the young winged man is portrayed down to the smallest detail, and the shape of his muscles is reminiscent of antique statues.

The work has always been accompanied by its preliminary study, a smaller canvas probably made by Guido Reni to study the composition beforehand, or to present the idea to the patron. Although it can still be found in the Pinacoteca Capitolina today, it can only be traced in the Sacchetti collection from 1726.

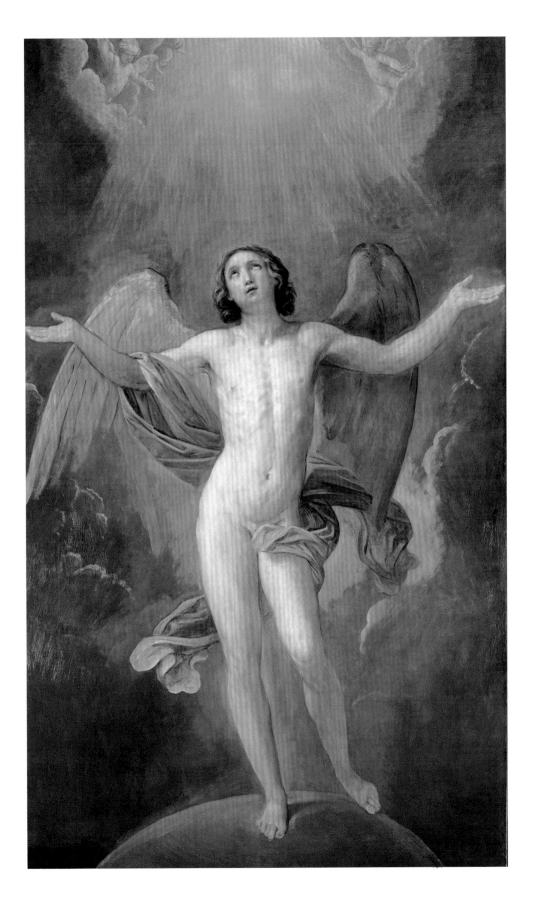

Oratory of Sant'Andrea
in the Church of San Gregorio al Celio

In the late sixteenth century the Oratory of Sant'Andrea al Celio, as well as the church of San Gregorio Magno and the Oratory of Santa Barbara, along with which it created a vast complex, lay outside the urban center as well as outside the circuit of the major places of worship in the papal city. The Jubilee of 1600, in addition to the Church's Counter-Reformation-inspired interest in restoring the origins and the ancient seats of Christian worship, led to a valorization of the building as ordered by Cardinal Baronio (1538–1607). The prelate, fascinated by the events in the life of Saint Gregory the Great, rediscovered the ancient construction, and assigned its restoration to Flaminio Ponzio (1560–1613) in 1601. The Lombard architect, in order to make the area of the two ancient oratories from the twelfth-thirteenth centuries more harmonious, added a third building to the right of the one devoted to the apostle, named for Saint Silvia, Saint Gregory the Great's mother. Ponzio also switched around the orientation of the Oratory of Sant'Andrea, closing off the medieval access on the slope of Scauro, and transforming the ancient counter-facade in the rear wall so that it could host the new high altar with an altarpiece by **Pomarancio** (circa 1530–circa 1597) portraying the *Madonna and Saints Gregory and Andrew* (circa 1602). The architectural transformation, which was completed when a small portico supported by four classical-style cipollino marble columns and capitals was built, led the way for a new decorative campaign for the interior. This was interrupted in 1606 following the patron's death, however. Thanks to Scipione Borghese (1577–1633), Cardinal Baronio's successor as protector and patron of the work, the restoration of the church was resumed in 1607, and included the realization of a stunning wooden coffered ceiling by Vittorio Ronconi. Also under Ponzio's direction, the building site involved the three most important artists who were active in Rome at the time: **Domenichino** (1581–1641) with the fresco depicting the *Flagellation of Saint Andrew* on the right wall, **Giovanni Lanfranco** (1582–1647) with the two monochrome figures of *Saints Silvia and Gregory* on the counter-facade, and, lastly, Guido Reni with *Saint Andrew Being Led to His Martyrdom* on the left wall and the monochromes representing Saints Peter and Paul to either side of the high altar.

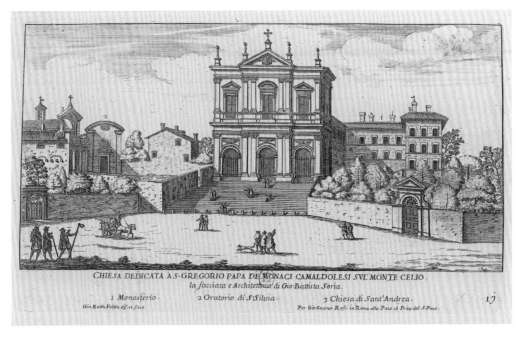

Giovanni Battista Falda, *View of the Church of San Gregorio Magnoal Celio
and of the Oratories*, 1665–1739, from *Il Nuovo teatro delle fabriche et edificii
in prospettiva di Roma moderna*, Paris, Bibliothèque nationale de France.

CHURCH OF SAN GREGORIO AL CELIO
Piazza San Gregorio al Celio, 1 – 00184, Rome
open every day 9am–noon; 4pm–6pm
the oratories of Sant'Andrea, Santa Barbara and Santa Silvia
can also be visited
www.monasterosangregorio.it

Saint Andrew Being Led to His Martyrdom

1608
Fresco, 410 x 640 cm

Andrew, brother of Peter the apostle and first
pope, was the founder of the first bishopric
of Constantinople. According to tradition, he
became a martyr during the empire of Nero
(37–68) in the Greek city of Patras.
He was likely sentenced to crucifixion following
his Christian preachings. Nonetheless, he
was not tortured in the same way as Jesus or
Peter, but rather was tied hand and foot to an
X-shaped cross, thereafter referred to as "Saint
Andrew's cross."
The scene painted by Guido Reni is situated
inside the eponymous oratory, which also
contains decorations portraying the last
moments in the apostle's life, in a context that
was entirely created by the Bolognese painters,
including Domenichino (1581–1641) and
Giovanni Lanfranco (1582–1647).
Depicted inside a frame as if it were a tapestry
hung across the wall, the setting for *Saint
Andrew Being Led to His Martyrdom* is that of
a country landscape: rising to the right is a hill
where there is a crowd in the midst of which a
number of people are placing the cross where
the apostle is soon to be martyrized. Andrew
is in the foreground, kneeling and almost
naked, surrounded by soldiers on foot and on
horseback. The saint has his back to the viewer
and, with his hands conjoined in prayer, he
gazes heavenward, pleading for God's mercy
and help. At the corners, several groups of
people are witnesses to the scene, especially
women and children. In Reni's day children
witnessed capital punishment so that they
would be aware of the punishment that awaited
those who did not abide by the laws. The
human figures here were shaped after classical
sculptures, which Guido had undoubtedly had
the chance to admire and study from close up.
The great attention to the naturalistic details
of the landscape are proof of Reni's skill at
reproducing, even in monumental historical
paintings such as this one, the smallest and
most accurate details resembling life.

Basilica of Santa Cecilia in Trastevere

After a papal brief granted it the status of a minor basilica, the church in Trastevere began to take on its current appearance in 1599, the year when the saint's body was identified and Cardinal Paolo Emilio Sfondrati (1560–1618) gave way to a series of commissions from the youngest and most promising artists on the Roman art scene. These included **Guido Reni, Paul Bril** (1554–1626), and **Stefano Maderno** (1576–1636), the sculptor of the famous statue reproducing the image of the martyr Cecilia in the same position and wearing the same attire as when her body was exhumed. The huge influence of this marble gem placed underneath the high altar was already rather evident inside the Basilica, as well as in all the works that were made regarding the saint from the seventeenth century onwards, which would have the same features. An example of this is the **Cappella del Bagno** situated along the right nave, which can only be visited by appointment or during the saint's feast day (November 22). The sacellum was built so that it corresponded to the underground where Cecilia was said to have suffocated after her executioners tried to behead her. The space was frescoed with scenes of hermits in a landscape by Paul Bril, while visible on the small cupola and the walls are scenes of the glory of Saints Cecilia and Valerian attributed to the Marchigiano painter **Andrea Lilli** (1570–post 1631). The decoration was completed with two works by Guido Reni, representing the *Coronation of Saints Cecilia and Valerian* and the *Martyrdom of Saint Cecilia*.

Probably already in existence during the fifth century, the Basilica we see today was built over the *domus* that is traditionally recognized as the place where Cecilia and her husband Valerian lived, and where the Roman noblewoman's death by suffocation took place. The ancient medieval structure is preceded by a portico where the sumptuous funerary monument of Cardinal Sfondrati is located. It was made around 1618 by Girolamo Rainaldi (1570–1655) featuring reliefs alluding to the works undertaken to identify the body of the Roman martyr. The structure is recalled by the elaborate ciborium (1293) by **Arnolfo di Cambio** (circa 1245–1302/1310), the monumental apse mosaic (circa 820) with an image of Christ blessing surrounded by Saints Peter, Paul, Cecilia, Valerian, and Agatha, along with Pope Paschal I donating the model of the church (notice the square nimbus that distinguishes him as being alive when the work was made unlike the saints who instead wear haloes), and the fresco of the *Last Judgment* by **Pietro Cavallini** (circa 1240–circa 1330) in the counter-facade, which can be visited by entering through the side door of the Convent of the Benedictine nuns. The current forms are the result of further eighteenth-century rearrangements, especially as concerns the fresco on the ceiling depicting the *Apotheosis of Saint Cecilia* (circa 1727) by **Sebastiano Conca** (1680–1764), and the outer facade and portico to a design by Ferdinando Fuga (1699–1782), summoned over the course of the eighteenth century by Cardinal Francesco Acquaviva d'Aragona (1665–1725) to complete the building.

Giuseppe Vasi, *View of the Interior Facade of the Basilica*, 1745–1765,
Rome, Istituto Centrale per la Grafica.

BASILICA OF SANTA CECILIA IN TRASTEVERE
Piazza di Santa Cecilia, 22 – 00153, Rome
every day
open 10am–12:30pm; 4:30pm–6:30pm
on the same day and during the same hours the crypt and excavations
can also be visited, as can the singing gallery with frescoes by Pietro Cavallini
Monday–Saturday
open 10am–12:30pm
Sunday
open 11:30am–12:30pm
www.benedettinesantacecilia.it

Martyrdom of Saint Cecilia

1601
Oil on canvas, 220 x 108 cm

When Paolo Emilio Sfondrati (1560–1618) became titular cardinal of the Basilica of Santa Cecilia, the ancient place of worship in Trastevere returned to the limelight in Rome's religious scene. The new prince of the church felt that the Bolognese artist who had just arrived in Rome was highly suited to arousing in believers a genuine devotion toward the saint, as had been established in the directives put forward by the Council of Trent (1545–1563). Cardinal Sfrondati already owned a copy of the much celebrated *Saint Cecilia* by Raphael (1484–1520) (see pp. 92–93), and in 1601 he commissioned Reni to paint the altarpiece for the Cappella del Bagno, where the artist was asked to represent the young woman's martyrdom. In this clear and simple composition, which instantly reveals the Reni's indebtedness to the Raphaelesque figures he had copied as a young artist in training in Bologna, Guido places the saint in the foreground where she opens her arms wide and turns her gaze heavenward, awaiting her death with seraphic serenity. Convinced of the goodness of her sacrifice she prepares to be crowned a heroine of faith by the two chubby angels depicted above her. Behind her a muscular executioner lifts his sword to behead her, while lower down two elements of a hypocaust, an underground central heating system conceived by the Romans, allude to the fact that she died in the baths of her home, later transformed into a basilica. Although the work was severely mutilated in the 1940s and the central part of the saint's body was later restored, it nonetheless helps us to fully understand Reni's transformation as soon as he arrived in Rome in 1601. In addition to the classical composition inspired by Raphael, the painter was clearly beginning to turn his attention toward the dramatic use of light by Caravaggio (1571–1610), even though he was not yet ready to move away from sixteenth-century tradition. Indeed, in the early twentieth century it was suggested that the canvas had actually been made by Raphael's pupil Giulio Romano (1499–1546), after it had for a long time been considered a copy of the original painting by Guido Reni.

The Coronation of Saints Cecilia and Valerian

1600
Oil on canvas, 238 cm Ø

While the *Martyrdom of Saint Cecilia* has always been considered an autograph work or a copy after a painting by Guido Reni, leaving aside the short period of time when it was attached to the name of Giulio Romano (1499–1546), the large tondo representing the *Coronation of Saints Cecilia and Valerian* has a less straightforward history. The biographer Carlo Cesare Malvasia (1616–1693) mentions, for example, only one painting for the basilica of Santa Cecilia without describing the subject, while Giovanni Pietro Bellori (1613–1696), a later biographer of the painter, refers to both paintings. In the late seventeenth century the work was believed to be a copy, while in the nineteenth century it was completely ignored by the sources. It was not until the past century that it was again presented as a work by Reni. However, the complex history of the canvas, which was completed in November 1601, it too commissioned by Paolo Emilio Sfondrati (1560–1618), must not obscure its value and central role in the artist's first Roman commissions. Positioned exactly opposite the *Martyrdom*, the tondo tells of an episode handed down from the so-called *Gesta di Santa Cecilia* (The Feats of Saint Cecilia), a fictionalized tale about the life of the saint. In it her newly wedded husband Valerian—who had converted to Christianity out of love for his chaste bride—returned to their home to find Cecilia deep in prayer together with a young man. Although Valerian was aware of the vow his wife had made on the day of their wedding that she would remain "immaculate in heart and body," he feared she had betrayed him and asked her to explain why there was a young man in their home. The martyr explained that the boy was actually an angel, but her husband wanted further proof. The young man was thus transformed into a beautiful angel who rose into the air and placed a crown of roses on Cecilia's head and one of lilies on Valerian's. The painter represents the miraculous apparition, during which the saint is wearing a silk and gold gown like the one she had on when her body was discovered while the sepulchre was being inspected at the cardinal's behest, in a simple and effective composition. The figures revealing the extent to which Reni was inspired by Raphael, akin to the ones he had made in the *Martyrdom* not too long before, are portrayed with light, compact hues contributing to the painting's remarkably limpid and clear final results. A noteworthy painting that draws to a close Guido Reni's very first years in Rome, and shows he is ready to absorb new stimuli and experiments from the papal city, to be expressed in painting that was clearly in the Bolognese manner, but that was beginning to change under the force of innovation.

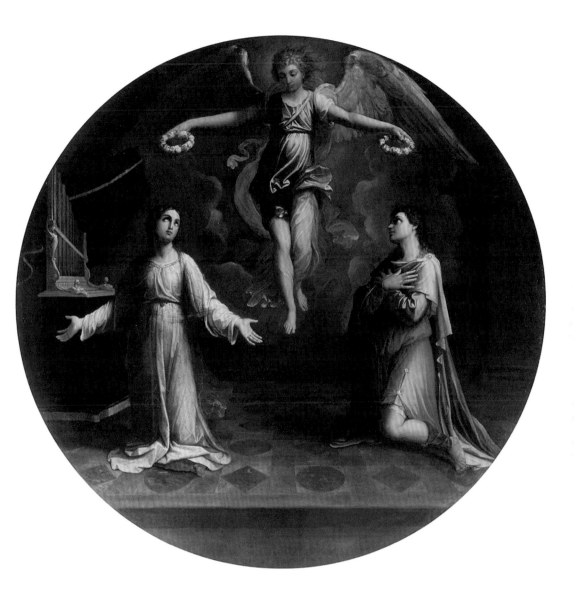

Galleria Nazionale di Arte Antica
Palazzo Corsini

When Guido Reni lived and spent time in Rome, Palazzo Corsini alla Lungara, currently one of the locations of the Galleria Nazionale di Arte Antica, looked different and also had a different name. In the early seventeenth century, the building was in fact still known as Palazzo Riario, named after Cardinal Raffaele Riario (1461–1521), the nephew of Sixtus IV and patron of the suburban complex built between around 1510 and 1512. Chosen by Christina of Sweden (1626–1689) as her residence while in Rome, it was finally acquired by the Corsini family in 1736. The noble dynasty of Florentine origin commissioned the restoration of the smaller villa of the Riario from the architect Ferdinando Fuga (1699–1782), the idea being to create a very large complex that could host the famous gallery of paintings and the equally noteworthy family library. From 1738 until around 1758, Fuga's interventions completely revolutionized the building's original appearance, turning the complex monumental site into one of the most famous Roman collections, whose origins can be traced in the first group of paintings collected by Cardinal Neri Maria Corsini (1685–1770) in the late seventeenth century. The acquisition in 1883 of the Palazzo and the family's entire estate by the Italian State made it possible to save the last of the great painting collections part of a trust, as well as one of the few eighteenth-century collections that had remained intact and were thoroughly documented at the dawning of the contemporary age. A collection that clearly and extraordinarily makes explicit the collecting tastes of eighteenth-century Romans, who knew how to choose and preserve masterpieces such as the *Triptych* with the *Ascension*, *Last Judgement* and *Pentecost* by **Beato Angelico** (1395–1455), or remarkable yet lesser-known canvases like the *Madonna of the Straw* by **Antoon van Dyck** (1599–1641). A small trove of masterpieces that includes the *Saint John the Baptist* by **Caravaggio** (1571–1610), the *Madonna and Child* by **Orazio Gentileschi** (1563–1639), along with the tragic *Death of Adonis* by **Jusepe Ribera called Lo Spagnoletto** (1591–1652) and the exquisite *Head of an Old Man* by **Peter Paul Rubens** (1577–1640). All works bearing witness to the golden age of Roman collecting.

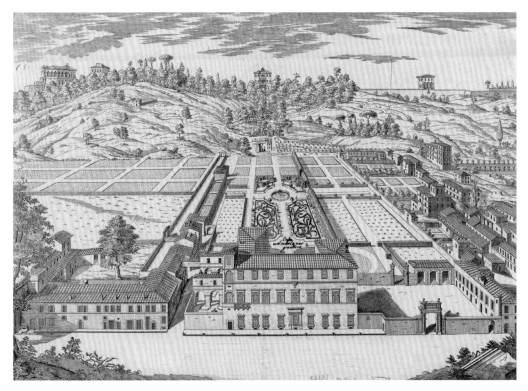

Anonymous engraver, *External View of the Villa of Cardinal Riario*, early
seventeenth century, Rome, National Institute of Archeology and Art History.

GALLERIA NAZIONALE DI ARTE ANTICA – PALAZZO CORSINI
Via della Lungara, 10 – 00165, Rome
Tuesday–Sunday (closed Monday)
open 9am–6pm (last entry before closing 5pm)
advance booking required during the weekend and for groups:
+39 06 32810
www.barberinicorsini.org

Salome with the Head of John the Baptist

Circa 1635
Oil on canvas, 134 x 97 cm

This is one of Guido Reni's finest paintings. Between the eighteenth and the nineteenth centuries the guidebooks dedicated to the city of Rome sang the praises of this essential yet dramatically narrative composition—so much so that it became one of the most copied of the artist's works.

The painting can be dated to around 1638–1639 and it joined the Corsini collection after it was acquired in the late 1630s by Cardinal Francesco Barberini (1597–1679). It was later donated to Pope Clement XII (1730–1740) by Monsignor Bardi.

The story of the Baptist and Salome is no doubt one of the most tragic events narrated in the Gospel of Matthew (14, 1–12): John was the first to preach early Christianity up until his encounter with Herod. The King of Judea had John arrested and imprisoned, advised to do so by Herodias who wanted him dead. Herod feared the Baptist's sense of justice and holiness, and so rather than kill him he decided to keep him imprisoned, and listen to his preachings and prophecies. During his birthday banquet, Herod had Salome, daughter of Herodias and his niece, perform a sensual dance. When she had finished dancing Herod told the young woman that because she had danced so beautifully he wanted to grant her a wish. Prompted by her mother, Salome asked for the Baptist's head. The king was distraught, but he sent for the prisoner and fulfilled her request. The executioner's then carried the Baptist's head to the banquet, horrifying the guests.

In this portrayal Salome is viewed against a dark background flooded by the light entering the scene from the top left corner, as she bears the head of John the Baptist on a plate. The young woman's beauty and sensuality is underscored by the sumptuous, rich drapery of her clothing, and jewelry valorized by precious stones and Baroque pearls. Salome's gaze, both bold and compassionate, communicates directly with the viewer, who feels they are a part of a sacred episode, participating in the announcement of the martyrdom that has just taken place.

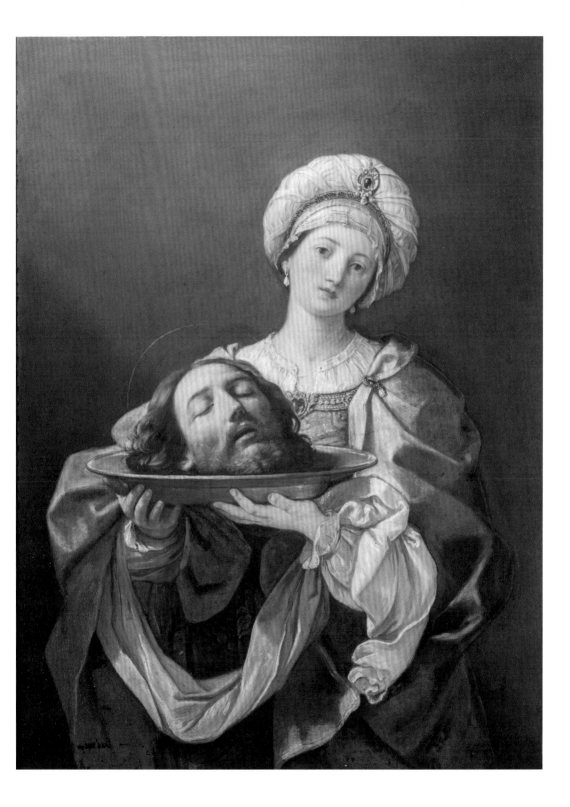

Vatican Museums and Palaces

Giovanni Battista Falda, *View of the Palazzo Pontificio at the Vatican*, 1665–1739, from *Il Nuovo teatro delle fabriche et edificii in prospettiva di Roma moderna*, Paris, Bibliothèque nationale de France.

The current collection of the Vatican Museums, which was founded in the sixteenth century around the courtyards of the papal residence, is one of the largest art collections in the world and a showcase for all the most significant art objects commissioned and accumulated by the popes over the centuries. Every year, around eighteen million visitors stroll through the seven kilometers of rooms and corridors to observe the works on display, making it the fourth most visited museum in the world.

The very first work that started the papal collections is still located in the so-called Cortile dell' Ottagono, previously known as the Cortile delle Statue: it is the *Laocoön*, a sculptural group that was inadvertently discovered by a plowman digging in 1506 and originally kept in Nero's Domus Aurea. The statue, which represents the extreme moment in the sacrifice of the priest and his children, after he warned his fellow citizens of the Trojan horse (he is famous for having said *Timeo Danaos et dona ferentes*, that is: "I fear the Danaans [Greeks], even those bearing gifts"), was not only the start of the papal art collections; it was also the inspiration for painters and sculptors to study antique artworks. Among the first to use this statue as well as others in the papal collection as a model were Raphael (1483–1520) and Michelangelo (1475–1564), the former for the

frescoes he made for the *Vatican rooms*, the latter for the complex decoration of the *Sistine Chapel*, the most important place of worship in the small State of the Vatican City.

For a closer look at Guido Reni's paintings and the papal collection, a visit to the **Pinacoteca Vaticana** is a must. At first housed in the Borgia Apartment, Pope Pius XI (1857–1939) commissioned a dedicated building from the architect Luca Beltrami (1854–1933). The Pinacoteca features sixteen rooms displaying paintings on mobile supports as well as detached frescoes, such as the paintings from the church of Santi Apostoli, dated to the twelfth-nineteenth centuries. Among the major works on display are paintings by **Giotto** (circa 1267–1337), **Leonardo** (1452–1519), **Raphael**, **Titian** (1488/1490–1576), and **Caravaggio** (1571–1610). One work that especially stands out in the rooms dedicated to seventeenth-century painting is Reni's monumental *Crucifixion of Saint Peter*, a work that was originally made for the church of San Paolo alle Tre Fontane. Commissioned by Cardinal Pietro Aldobrandini (1571–1621), Reni's painting represents the artist's classicism that was the result of his artistic training in Bologna, and his encounter with Caravaggio's dramatic use of light and dark (1571–1610).

In addition to the Egyptian and Etruscan collections, both sacred and profane, also worthy of note is the *Collection of Modern Religious Art*, which contains around eight hundred works by eighteenth- and nineteenth-century artists, including Rodin, van Gogh, De Chirico, Matisse, and Bacon. There is also the *Missionary-Ethnological Museum*, which since 1926 has gathered work from around the world, mostly gifts to the popes, but also objects collected during the missions of institutions like the Collegio Propaganda Fide outside of Europe.

Works by Guido Reni

 Frescoes for the Room of the Aldobrandini Wedding: Stories of Samson
circa 1601–1602, frescoes, 241 x 166 cm, 350 x 166 cm, 241 x 166 cm

Crucifixion of Saint Peter
1604–1605, oil on wood, 305 x 171 cm

 Frescoes for the Sala delle Dame: Ascension, Pentecost, Transfiguration
1608–1609, frescoes, 182 cm Ø, 182 x 373 cm, 182 cm Ø

Saint Matthew and the Angel
circa 1630, oil on canvas 79 x 66 cm

Virgina and Child with Saints Thomas and Jerome
circa 1632–1633, oil on canvas, 340 x 210 cm

 VATICAN MUSEUMS AND PALACES
Viale Vaticano – 00165, Rome
Monday–Saturday (closed Sunday) open 9am–6pm (last entry before closing 4pm) every last Sunday of the month open 9am–2pm (last entry before closing 12:30pm) advance booking required: www.museivaticani.va

Frescoes for the Room of the Aldobrandini Wedding: Stories of Samson

circa 1601–1602
a. *Samson Killing the Lion*, 1608–1609, fresco,
241 x 166 cm [on the following pages]
b. *Samson Slaying the Philistines*, 1608–1609, fresco,
350 x 166 cm [on the following pages]
c. *Samson Removing the Gate of Gaza*, 1608–1609,
fresco, 241 x 166 cm [on the following pages]

Between August and November 1608, Reni was busy working on the new rooms in the Palazzo Apostolico Vaticano. The artist had been summoned to the major work site by Cardinal Scipione Borghese (1577–1633) on behalf of his uncle, Paul V (1552–1621). Elected three years earlier, the pope was engaged in the extraordinary decorative program for the new rooms built near what was would eventually become Saint Peter's. The Bolognese painter was assigned to decorate two large rooms: the first of these, currently known as the *Room of the Aldobrandini Wedding*, was the antechamber to the pope's nephew's new living quarters. This rectangular space, currently part of the Vatican Museums, is named after a famous fresco from the Augustan Age that was detached and housed in a museum soon after it was rediscovered in Rome, on the Esquiline Hill, near the church of San Giuliano l'Ospitaliero—which no longer exists—in 1601. The work, which was previously in the collection of Cardinal Pietro Aldobrandini (1571–1621), was acquired in 1818 by Pius VII (1742–1823), and installed here in 1838. The fresco decoration is not linked to the theme of the ancient finding preserved here, but is instead related to the biblical feats of Samson told in the Book of Judges in the Old Testament. Following a largely pre-established iconographic plan, inside a decorated stucco frame Guido Reni painted three episodes from the life of Samson, alternating the scenes with two inscriptions reminding the visitor of the name of the pope at the time (Paul V) and the year the work was made (the third

of his reign). The three scenes illustrate the triumphs of Samson: *Samson Removing the Gate of Gaza*, *Samson Slaying the Philistines*, and *Samson Killing the Lion*. The choice of this uncommon theme is related to the figure of Cardinal Scipione, who probably wished to be identified with the biblical judge. The cycle was intended to start from the portrayal of the Gates of Gaza, strategically placed above the entrance. Here the hero of superhuman strength is represented hoisting the monumental gates to the city onto his shoulders and carrying them to the top of a mountain, after ripping them off in the middle of the night to the amazement of the daring people of Gaza. At the center Samson is instead portrayed raising a donkey's jawbone—according to the Bible his sole weapon—the moment before he kills two Philistines. In the final work, Reni represents the famous episode of the lion: when Samson went down to the vineyards of Timnah he was attacked by the ferocious animal. But the Spirit of the Lord having come upon him, he tore the lion apart with his bare hands. Albeit very hard to appreciate in their original form, the works still demonstrate Guido Reni's great technical skill and style as a painter of frescoes. The works were detached and transferred to canvas in the second half of the nineteenth century. They were again restored in 1962, and they were later mounted on masonite. The various supports and numerous interventions have no doubt affected the artist's original work, but they have not in any way hindered the power of expression of his creations.

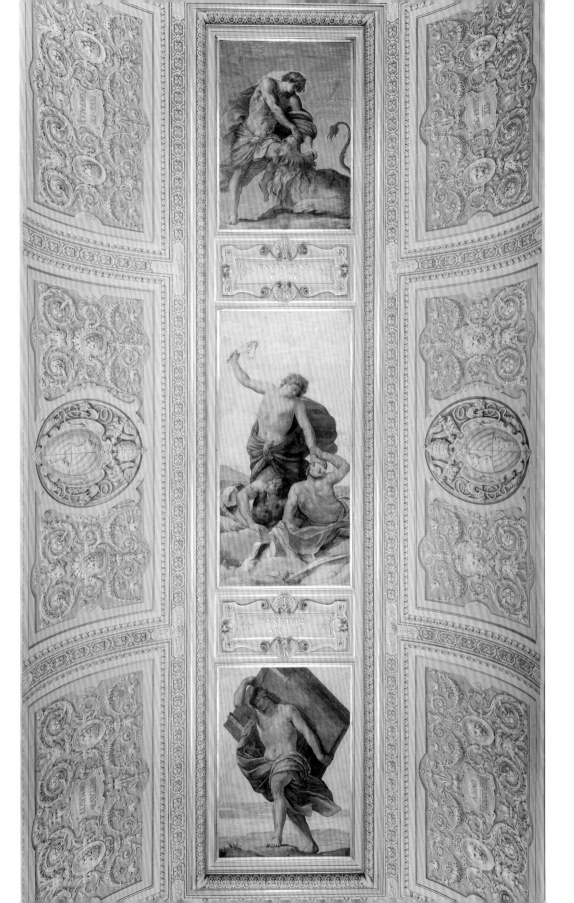

PAVLVS V
P M

PONTIFIC
AN III

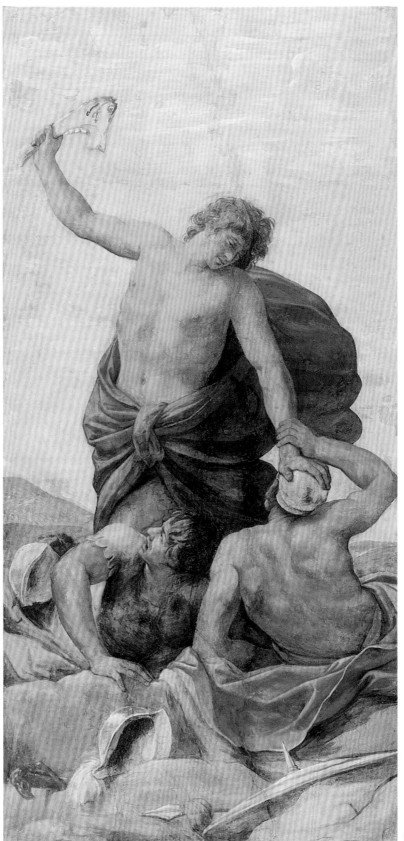

b.

C.

Frescoes for the Sala delle Dame: Ascension, Pentecost, Transfiguration

a. *Ascension*, 1608–1609, fresco, 182 cm Ø [on the following pages]
b. *Descent of the Holy Spirit (Pentecost)*, 1608–1609, fresco, 182 x 373 cm [on the following pages]
c. *Transfiguration*, 1608–1609, fresco, 182 cm Ø [on the following pages]

During the six months that Guido Reni spent painting the Stories of Samson for the antechamber of Scipione Borghese's (1577–1633) apartment (see the previous entry), he was also active in the work site to decorate another room in the same Palazzo Apostolico. Right above the *Room of the Aldobrandini Wedding* the painter made three other frescoes to decorate the so-called *Sala delle Dame*. The room, which is about the same size as the room below it, led to the pope's living quarters located in the newly completed wing. The inscriptions present in the room confirm the same date of completion for the frescoes in the *Room of the Aldobrandini Wedding* (ANNO SAL. MDCVIII) and also that they are both a part of the major renewal project promoted in those years by Paul V (1552–1621) for the Vatican Palaces. Once again Reni painted inside sumptuous, gilded stucco frames, with just three spaces available in which to add the scenes according to a specific iconographic program. In the room on the lower floor the reference to the Old Testament likened the figure of Samson to that of the charismatic cardinal nephew; here instead the reference to the New Testament imagines the pope as an indispensable spiritual guide. In the first tondo above the entrance door Reni painted the *Transfiguration*, the event when Jesus led three of his disciples, Peter, James, and John, up to Mount Tabor where he was transfigured,

his body and clothes becoming dazzlingly bright. Jesus then rose heavenwards and spoke with Moses (left) and Elijah (right). In the rectangular panel at the center of the room the artist painted the choral scene of the *Descent of the Holy Spirit*. Above the heads of the disciples reunited with Mary (at the center) the spirit of the Lord descends in the form of a flame, offering the gift of the languages of the world. The small cycle ends with the second tondo, in which the artist represents the *Ascension of Christ*. Here, to the amazement of all those present, the son of God rises up to the heavens with both his body and his soul. While the feats of Samson are to be interpreted as a metaphor for the figure of Scipione, symbolizing the Church's militancy through which it participates in the affairs of the world, the three mysteries of the faith depicted here symbolize the spiritual power of the papacy, of which the Church remains the sole reference. The surrounding stucco decoration contributes to this interpretation as well: its shape is reminiscent of a canopy that, like the ones used in papal celebrations, covers the heads of the visitors and celebrants. In this great "stage prop" Reni defines his very particular language of solemn and idealized beauty. Through his use of color and great technical skill, this language becomes the perfect tool to communicate the vibrant and active papacy of the Borghese.

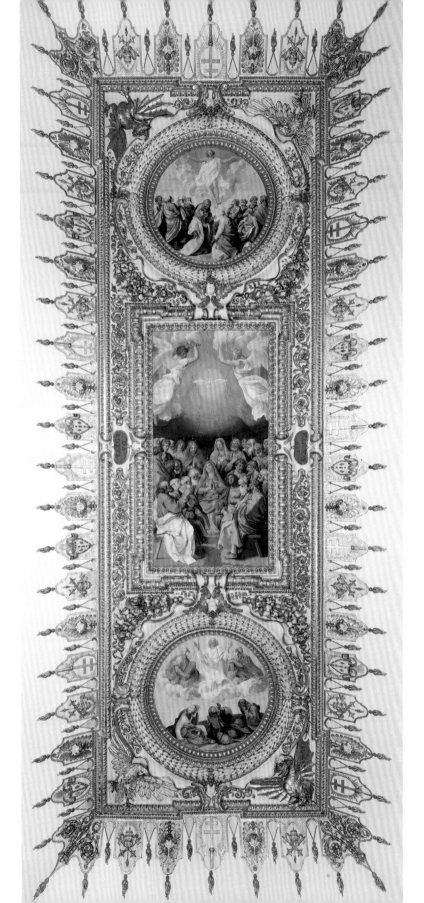

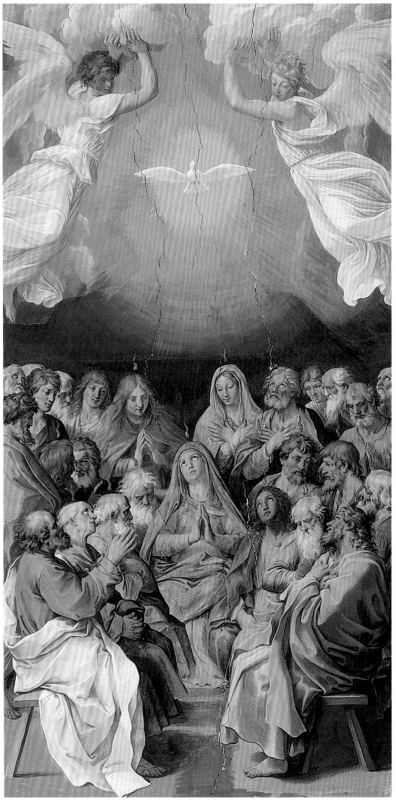

b.

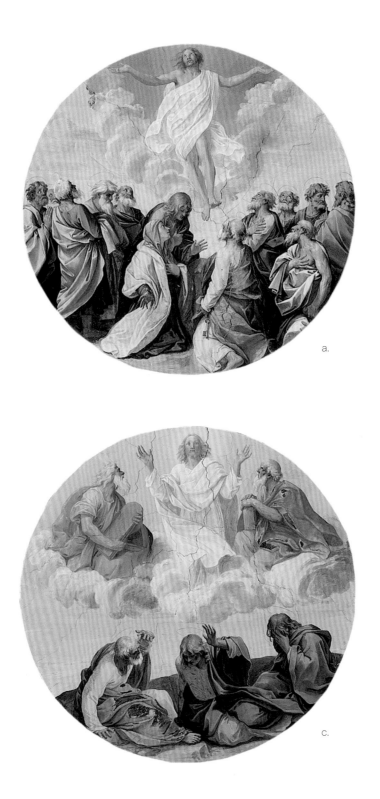

a.

c.

Self-Portrait, Uffizi Gallery.
circa 1635, oil on canvas, 48,5 x 37 cm

Guido Reni in Rome. Researching the Documents

Although it is by no means exhaustive, the purpose of this list of documents is to offer a setting for Guido Reni's activity in Rome, and to demonstrate that his story is told not only by his works but also by the records from the time when he lived and the places where he went.

To give readers an idea of how the research has advanced to this regard, listed here are some of the archival records, including both accounts and letters, concerning the painter's time in Rome. The list was drafted starting from contributions about Reni previously released in a number of prestigious publications. The foremost reason for this appendix is to arouse the reader's curiosity and provide an opportunity to find out more about the artist.

The works cited in the documents and identified by the critics are evidenced in brackets.

1601
January

Guido Reni receives a payment in the Roman branch of the bank of Juan Errera and Ottavio Costa: "Magnifici SS.ri Herrera e Costa, Vi piacerà pagare al Sig.r Guido Pittore Bolognese scudi sessanta di moneta quali se li pagano a nome dell'Ill. mo Sig.r Card. Sfondrato per altretanti pagati a me in maggior somma et in una partita per Bologna dal detto Ill.mo Sig.r Cardinale e pigliandone ricevuta mettete a mio conto […] conceda ogni bene. Di casa […] Genáro 1601. Delle SS.rie VV.re per servirle prontamente D. Angelo Maria da Milano Procuratore Generale degli Olivetani."

11 October

Guido Reni is paid "scudi centoventi di moneta quali sono p. un quadro di S. Cecilia, et p. altri lavori fatti da lui fin a questo giorno p. serv. n. ro che pigliandone ricta. Di casa a XI d'Ottobre 1601"
[The payments should refer to the *Martyrdom of Saint Cecilia* and the *Coronation of Saints Cecilia and Valerian* in the Basilica of Santa Cecilia in Trastevere].

1602
15 November

Guido Reni receives payment from the bankers of Cardinal Sfondrato iqual to "scudi cinquanta di m.ta quali sono a conto di lavori, ch'egli ha fatto per res n.ro che pigliandone ricevuto di casa a 15 d. Nov. 1602"

14 December

Guido Reni is in Rome as attested to in a notary deed as "D. Guidus q. d. Danielis Bononiensis pictor in urbe."

1603
31 January – 30 April

Guido Reni receives in Rome, by the Attorney General of the Olivetans, an advance payment of 50 *scudi* for a painting to be made for the cloister of San Michele in Bosco upon returning to Bologna.

1604
18 February

Guido Reni signs a document as *rettore* of the Accademia di San Luca.

18 September

From the bankers of Cardinal Sfondrati, Guido Reni receives "scudi venticinque di moneta [che] sono il prezzo di alcune pitture fatte p. serv. nro et. p. saldo e final pagamento di quanto può pretendere da noi [...] Di casa 18 Sett. 1604"
[The work was the *Christ at the Column* now at the Städel Museum, Frankfurt, inv. 1103].

28 October

Guido Reni the painter is recorded in Loreto to judge the work of the Bolognese painter Lionello Spada in the Sala del Tesoro of the Santa Casa: "Giodo Rena Pittore venuto di Roma p. tal' effetto mandato dall'Illmo et R.mo S.r Card.le Gallo Protett.re."

27 November

Guido Reni receives "sc. cinquanta moneta pagatoli a bon conto d'un quadro che fà per la Chiesa delle Tre fontane Mazinghi [...]"

[The work was identified as the *Crucifixion of Saint Peter* now at the Pinacoteca Vaticana, inv. 40387].

1605
2 June
Ruggero Tritonio, a Friulian abbot, deposits in Rome an advance payment for an altarpiece for the Abbey of Pinerolo: "Signori Errera e Costa saranno le Signorie Vostre contente pagare per me a ms. Guido Pittore Bolognese dodeci scudi di moneta, quali sono a conto d'un quadro, che mi fa per la mia Abbadia. Di Cancelleria alli 2 di Giugno 1605 /Ruggiero Abbate Tritonio scudi 12 Io Guido Reni ho riceputo dalli sopradetti Signori li sopradetti scudi dodeci. Io Guido Reni."

31 August
Guido Reni is to receive the balance, 50 *scudi*, for the work he made for the church of San Paolo alle Tre Fontane.

1606
19 April
Guido Reni receives the balance for his execution of the *Assumption of the Virgin* in the Abbey of Pinerolo: "Signori Errera e Costa saranno le Signorie Vostre contente pagare per me a ms. Guido Pittore Bolognese sessanta scudi di moneta; quali sono per saldo di una tavola che mi ha fatta del Assuntione de la Madonna da mandarsi all'Abbadia. / Di Cancelleria alli 19 d'Aprile 1606 / Ruggiero Abbate Tritonio / scudi 60 // Io Guido Reni ho riceputo dalli sopradetti Signori li sopradetti scudi sessanta per saldo della sopradetta tavola questo di 19 aprile 1606 / Io Guido Reni."

22 October
The painter is recorded in Rome at the Accademia di San Luca where along with the painter Francesco Albani he makes a donation to the chapel of the saint: "Adì di 22 ottobre 1606, elemosina e p. la cappella il giorno di S. Lucha. Sg. Guido 30 sc. St. Francesco Albani, sc. 30."

24 December
The name Guido Reni is recorded among those entering the Accademia di San Luca.

25 December
Guido Reni receives from Cardinal Sfondrati a payment of 25 *scudi* "for the painting of Saint Cecilia"
[The work was identified as the *Saint Cecilia* now at the Norton Simon Museum, Pasadena, inv. F.1973.23.P].

1607
4 November
Guido Reni is witnessed to be *rettore*, along with Orazio Borgianni, of the "Venerabilis Congregationis Sancti Lucae Pictorum, et sculptorum Urbis."

1608
5 August
Guido Reni painter is paid "cudi cento di moneta [...] a bon conto delle Pitture che fa nelle stanze nuove sopra il portone della panettaria."

10 September
Paid to "Guido Reni Pittore scudi cento di moneta a bon conto delli pitture fatte nella volta delle stanze noue sopra il portone della panatteria."

15 November
Paid to "Guido Reni pittore scudi cinquanta moneta a buon conto delle pitture che fa nelle stantie nuoue di Palazzo Vaticano"
[These payments were identified as being for the frescoes in the *Room of the Aldobrandini Wedding* and for the ones in the *Sala delle Dame* of the Vatican Palaces, which kept the painter engaged between August and November 1608].

1609
6 April
Cardinal Montalto's account book lists a payment to Guido Reni: "Signori Herrera e Costa vi piacera pagare à Guido Bolognese pittore s. 89 di moneta quali sono per prezzo d'un quadro di una Assunta da lui fatta per servizio nostro, et datecene debito [...]."

30 July
Guido Reni promises to pay the Accademia di San Luca 2 per cent of the amount received for works for the Palazzo Apostolico.

26 September
Paid "scudi Centocinquanta moneta [...] a Guido Reni Pittore."
"A ms. Guido Reni Pittore scudi cento cinquanta moneta sono per resto di scudi 400 simili che importano diverse pitture fatti da lui nelle volte delle camere nuoe una al piano dell'appartamento di N. S. sopra la panatteria et l'altra sotto la detta doue habbita l'Ill.o Borghese così stimati da Gio. Batta. Ricci di Nouarra eletta per parte della cam.a et Gir. Massei da Lucca eletto da d.o pittore con interuento del S.r Giulio Buratti boni alla fabriche ordinarie."

30 September
As agreed on 30 July of the same year, the painter pays 8 *scudi* to the notary, who will make the payment to the Accademia di San Luca.

3 October
Paid to "Ms. Guido Reni pittore scudi cento moneta a bon conto delli lavori fatti et da farsi"
[First payment referring to the work site for the Cappella dell'Annunziata at the Quirinal Palace].

25 October
The account book kept by Guido Reni records that the painter was paid "Dal Car.le Borghese per le pitture a S. Gregorio, sino a questo giorno ho ricevuto scudi 300"
[Payment referred to the frescoes for the complex of San Gregorio al Celio].

28 October
The account book kept by Guido Reni records that the painter received the sum of "Cento scudi a bon conto delle pitture che si farano nella Capella nova di Monte Cavallo"
[Payment referred to the Cappella dell'Annunziata at the Quirinal Palace].

29 October
The account book kept by Guido Reni records the delivery "A messer Giovanni Lanfranco a bon conto a scudi dodici per le pitture a S. Gregorio et S. Bastiano"
[The payment could refer to the frescoes of *Saints Peter and Paul* which are now lost].

5 November

Guido Reni writes: "Pagai scudi settenta moneta per la piggione di sei mesi della casa del Sig. Matei."

7 November

Guido Reni records in his account book that he received "Dal Car.le Borghese scudi cento per il resto delle pitture di S. Gregorio et il S. Pietro a S. Bastiano, et questo per il restante saldo di scudi quatrocento."

16 November

Recorded in Reni's account book is a payment of "Scudi otto a Messer Giovani Lanfrancho, per resto delle pitture fattomi a S. Gregorio et S. Bastian" [The payment could refer to the frescoes with *Saints Peter and Paul* which are now lost].

17 November

Recorded in the account book is the payment of "Scudi otto e mezzo per un ritratto fatto da Guido et rittocato del Car.le Sannesio."

15 December

Guido Reni is mentioned during the meeting of the Company of Painters in Bologna, described as follows "Sta a Roma, Pittore del Papa."

1610

6 January [and following months]

Guido Reni's name appears as that of the author of a drawing portraying one of the events in the life of Saint Philip Neri engraved by the artist Luca Ciamberlano. The sole citation of Reni's name will also appear in other payments made to Ciamberlano: on 6 January, 4 February, 14 March, 27 March, 22 April, 19 May, 27 June, 10 July, 12 July, 12 August, 28 August, 14 September, 24 September, 2 October and 16 November. [Some of Ciamberlano's prints have been identified: *Saint Philip Neri Curing Pope Clement VIII*, National Gallery of Canada, Ottawa, inv. 28150; *Saint Philip Neri Curing Pope Clement VIII*, Gallerie degli Uffizi, GDS Fondo Santarelli 3476S, Florence; *Saint Philip Neri in Prayer*, Gallerie degli Uffizi, GDS Fondo Santarelli 3477S, Florence]

9 January [and following months]

First payment of 100 *scudi* to Guido Reni for a series that can entirely be referred to the Cappella dell'Annunziata at the Quirinal Palace. That same year the painter was paid for the same work site also on 3 April (100 *scudi*), 5 June (100 *scudi*), 21 August (100 *scudi*), 18 September (60 *scudi*), 23 October (60 *scudi*), 13 November (40 *scudi*) and 11 December (80 *scudi*).

10 January

In his account book Guido Reni records having received "cento scudi à bon conto delle Pitture che si fano nella Capella d[i] Monte Cavallo."

13 June

Guido Reni is the godfather at the christening of Laora, daughter of Bernardo Bencivegni of Parma and of Giovanna di Marco of Reggio, at the church of San Marcello al Corso.

25 September

First payment of 100 *scudi* made to Guido Reni "a buon conto delle pitture fare a da farsi" for the Cappella Paolina in the Basilica of Santa Maria Maggiore. As of this date, the painter, as part of a commission headed by Cavalier d'Arpino, will reappear on several occasions paid either individually or along with the other artists involved in the work. During this year he will be paid for the same commission on 16 October (80 *scudi*), 29 October (80 *scudi*) and 26 November (80 *scudi*).

10 November

The engraver Luca Ciamberlano, working on a group of prints on the subject of Saint Philip Neri, receives "dal Padre Francesco Zazzara scudi quindici per comprare tanto drappo da vestire per donare al Sig. Guido per haver lui fatto quindici disegni di dette historie. Et in fede li ho fatto il presente ricevuti s. 15 e più per il suddetto al Sig. Guido s. 2."

15 December

Guido Reni states that he received "Scudi vinti a buon conto d'un stendardo da Messer Gallo" [The work was identifed as the *Processional Banner of Saint Francis*, now at the Museo di Roma-Palazzo Braschi, Rome].

1611

2 January [and following months]

As was already the case during the previous year (1610), Guido Reni's name appears as that of the author of a drawing for the engraver Luca Ciamberlano. The name Reni alone will also appear in other payments made to the master engraver: on 9 January, 20 February, 12 April, 20 October, and 11 November.

8 January

Payment of 200 *scudi* "delli lavori fatti e da farsi" for the Cappella dell'Annunziata at the Quirinal Palace, repeated on 5 March of the same year (100 *scudi*).

5 March

Given to Guido Reni Pittore and to other painters involved in the decoration of the Cappella Paolina in the Basilica of Santa Maria Maggiore as advance payment for "le pitture fatte e da farsi." That same year the painter also received payments on 19 March (80 *scudi*), 23 April (80 *scudi*), 14 May (80 *scudi*), 18 June (80 *scudi*), 23 July (80 *scudi*), 24 September (80 *scudi*), 22 October (80 *scudi*), 26 November (80 *scudi*) and 9 December (80 *scudi*).

15 June

Recorded in Guido Reni's account book is a payment "Per la piggione che mi paga il Car.le scudi vinticinque per il semestre passato."

1 October

Final payment for the balance of the work done for the chapel of "N.S.re delle quattro stanze di monte Cavallo" in the amount of 960 *scudi*. In the margin it says that the payment "non ha avuto effetto che sin è fatto un altro a bon conto di scudi 800."

17 October

"Al s.r. Guido Reni scudi ottocento m.ta a bon conto delle pitture che ha fatto nella cappella di N. S.re delle quattro stanze di monte Cavallo oltre scudi 1040 ricevuti a d.o. conto che così pag.ti con sua ricevuta selì faranno boni al conto della fab.e di M. Cav. o."

1612

7 January

Payment on behalf of Cardinal Scipione Borghese

in the amount of "tventicinque m[one]ta per la pigione della Casa che li paghiamo per sei mesi anticipati a ragione di cinquanta l'anno con sua ricevuta saranno ben pagati."

16 February

Final payment of 160 *scudi* to Guido Reni as the balance for the work site of the Cappella dell'Annunziata at the Quirinal Palace for which the painter was paid a total of "doi mila scudi simili."

10 April

Guido Reni is paid through Luca Ciamberlano 20 *scudi* to retouch *The Virgin and Saints Nilus and Bartholomew* by Annibale Carracci in the Farnese chapel of the monastery of Grottaferrata.

16 April

Guido Reni is attested to in a notary deed in Naples in which he nominates Luca Ciamberlano his legal proxy in Rome.

23 April

Payment in favor of Guido Reni for "le pitture fatte e da farsi" in the Cappella Paolina of Santa Maria Maggiore.

6 May

For Guido Reni "scudi centocinquanta di m.ta a buon conto della pittura fatta nella Cappella [...] in S.ta Maria Mag.re oltre altri scudi 1357 b. 60 simili che di già ha avuto a q.o conto."

19 June

To Guido Reni painter "scudi cento novantadoi b. 40 m.ta se la fanno pagare per resto et intiero pagamento di tutte le pitture da lui fatte nella Cappella che s.ta di Nro. S. re. fa fare in Santa Maria Maggiore et quanto oltre altri scudi 1507.60 simili compresovi l'Azzurri che di già havuto a d.o conto et con sua ric.ta detta confromita sa faranno boni al Conto della fab.a di d.a Cappella."

20 June

Payment to Guido Reni "per il disegno di S. Carlo et il Beato Padre in foglio una medaglia del Beato Padre di valua di s.1.20."

14 September

To Guido Reni Painter "scudi dugento di m.ta quali se li fanno pag.re oltre scudi 1700 simili che hebbe per pagm.to delle pitture fatti da lui (a S.M.M.) [...] non ostante che l'ultimo mandato dicesse per resto, atteso che habbiamo giudicato doverseli dare li detti scudi 200 di più a cto. a detto Reni."

7 October

The completion of the inscription of the Cappella Paolina, which was begun in the spring, is recorded. The payment reads "per haver segnato e colorito ancora l'Inscrittioni nelle 4.ro Historie dipinte dal Sig[no]r Guido."

20 November

The name Guido Reni appears for the last time as the supplier of drawings as part of a payment to the engraver Luca Ciamberlano.

10 December

The Archivio Borghese shows payment "per la colla depinta del quadro della volta di d[ett]a log[gi]a a lon[go] p[almi] 31 lar[go] p[almi] 12 ¼ et la colla sim[il] e delli doi mezzi tondi"
[The payment was found to correspond to the first phases of the making of the fresco for the ceiling of the *Casino dell'Aurora*].

1614

15 February

In a letter addressed to Cardinal Maffeo Barberini, Guido Reni states that he must take his distance from the decoration of the tribune in San Domenico in Bologna so that he can complete the works he began in the Rome for Scipione Borghese, with evident reference to the decoration of the Casino dell'Aurora: "Supplico V:S: Ill.ma a perdonarmi se troppo li trattenerò il suo quadro dovendomi prima che parti di Roma servire di alcune Pitture l'Ill.mo Sig. Cardinale Borghese poi sarò subito a servire V.S. Ill.ma [...]."

25 February

Guido Reni is the godfather at the christening of Alfonso, son of Marzio Galassino and Lavinia Pirardi, at the parish of San Lorenzolo in Rome.

2 April

Guido Reni is paid in advance by the Bolognese Senate for the *Pietà dei Mendicanti* intended for the church of Santa Maria della Pietà, through the representative for Bologna in Rome.

6 April

Along with other painters who are members of the Company (Antiveduto Gramatica, Jusepe de Ribera, Ottavio Mario Leoni, Giulio Dolabella, Giovanni Lanfranco, Domenichino, Antonio Carracci, Marcello Provenzale, Pierfrancesco Alberti, Pompeo di Giovanni, Battista Ferrucci, Marzio Ganassini, Girolamo Massei) Guido Reni commits to donating the sum of 100 *scudi* to contribute to the building of the church of San Luca.

8 August

Payment to "Guido Reni Pittore per saldo di doi quadretti fatti a olio et altre pitture fatte alla loggia del Giardino di Monte Cavallo"
[The payment recorded has been found to correspond to the completion of the frescoes for the *Casino dell'Aurora*].

10 September

Guido Reni and Ottavio Leoni, *principe* of the Accademia di San Luca, are summoned following a suit involving the painter Giovanni Baglione. The latter goes before the judicial authorities after an expertise report is made concerning one of his altarpieces and carried out by the two painters on 7 September 1614. The judge, Bernardino Bonoianni, establishes a compromise between the parts, which will last three months and is renewable.

4 October

Guido Reni is paid 72,50 *scudi* to paint the *Vision of Saint Philip Neri*, a painting that is now in the rooms of the Congregation and that at one time was destined to the chapel dedicated to the saint in Santa Maria in Vallicella.

1 November

Guido Reni sends a letter to Rome to an unknown correspondent announcing his return to Bologna: "io sono ritornato a Bologna per finire molte cose, che alla partita mia lasciai cominciate [...]."

1617

24 April

A notary deed states that: "Adi 24 aprile1617 in Roma / Io Andrea Benedetti ho auta una S. Cecilia

[…] meza figura de mano di signor Guido Reni quale ho auta a bon conto de quelo devo dal signor Pietro Erera ed in fede o fata la presente de mano propria Andrea Benedetti."

1625
23 August
Guido Reni writes from Bologna to Cardinal Ludovico Ludovisi, the person who commissioned the altarpiece for the church of the Santissima Trinità dei Pellegrini in Rome, promising that the painting would be finished in a short amount of time.
[The work was identified as the *Holy Trinity*, now at the church of the Santissima Trinità dei Pellegrini, Rome].

1627
19 August
Guido Reni is recorded to be in Rome, from where he writes a letter to Antonio Galeazzo Fibbia: "Finalmente, per non disgustare il sig. Card. Barberino, so restato per far la tavola di S. Pietro, la quale hanno determinato si faccia fresco. Mi hanno licenziato, e me ne volevo venire. […] volendo poi, che fatta sarà la tavola, e poco altro, ritornare a casa per finire le opere che sono obbligato, non mi mettendo conto finirle a Roma, dove si spende all'ingrosso, ed io non posso fare parsimonia, né ritirate […]"
[The reference to the painting of Saint Peter's corresponds to the work that was never made and was meant to represent the *Trinity*].
14 September
Guido Reni receives 400 *scudi* from the Reverenda Fabbrica Saint Peter's "a conto della tavola che deve fare in s. Pietro"
[The reference to the painting for Saint Peter's Basilica corresponds to the work that was never made that was meant to represent the *Trinity*].
24 October
Anna Colonna weds Taddeo Barberini, nephew of the Pope. Urbano VIII gives the couple a painting by Reni depicting the *Virgin and Child*
[The work is likely the *Virgin and Child*, now at the Kunsthistorisches Museum in Vienna, Gemäldegalerie, inv. 246].
14 November
In a general assembly of the Academy of Painters and Sculptors the names of the candidates for the position as *principe* for the following year are put forward. Guido Reni is one of those nominated for the position.
28 November
Guido Reni is present at the general assembly of the Academy of Painters and Sculptors where lots are drawn and the following are elected: Baldassarre Croce as *principe*, Girolamo Nanni as first *rettore*, and Giovanni Contini as second *rettore*.

1628
3 January
Guido Reni gives back to the treasurer of the Reverenda Fabbrica of Saint Peter's the sum of 400 *scudi* which he received on 14 September the previous year to paint the altarpiece for the Saint Peter's Basilica.

[The reference to the painting for Saint Peter's Basilica corresponds to the work that was never realized that was meant to represent the *Trinity*].
9 September
"A di 9 Sett (1628) sc. 320 m.ta in cr'o a Sacchetti pagati con m'to n.o 1601 al S.r Abbe Onofrio del Monte per prezzo di tre statue magg.ri del naturale, tre teste d'Imperatori antichi con loro petto, e due testi minori del naturale di marmo rosso, e per un quadro di S. Caterina delle Ruote mezza figura fatto da Guido Reni senza Cornici, il tutto comprato delle robbe del gia S.re Cardinal del Monte al g.e 219…-320."
5 November
Guido Reni is present at the general assembly of the Academy of Painters and Sculptors where, with lots drawn, the new *principe*, Giuseppe Cesari, is elected, as well as the *principe* for the following year, Antonio Tempesta.

1629
11 November
Guido Reni, because he is not present in Rome, delegates Domenico Zampiero to the general assembly of the Academy of Painters and Sculptors where Domenichino is elected *principe* of the Academy, Nicolas de La Fage first *rettore*, and Bartolomeo Balducci second *rettore*.

1645
21 April
To Giuseppe Reni [*brother of Guido*] 34 *scudi* in coins as per resto et int.o pagamento del pr'o of a painting made by Guido Reni, representing the Adoration of the Magi consegnato à D. Servio N'ro Guardarobba che … q.o di 21 April 1645 sc. 34
[The work was identified as the *Adoration of the Magi*, now at the Museum of Art, Cleveland, inv. Leonard C. Hanna, Jr. Fund 1969.132].
26 April
Et à di detto 34 scudi in coins paid with receipt number 266 to Giuseppe Reni for the remainder and entire payment for the price of the painting made by Guido Reni, representing the Adoration of the Magi conseg.to come s.a … gle 575, et in q.o 461 sc. 34
[The work was identified as the *Adoration of the Magi*, now at the Museum of Art, Cleveland, inv. Leonard C. Hanna, Jr. Fund 1969.13232].

Index of Places

The places listed in this index actually exist and are mentioned in this guidebook, with the sole exception of the references to Rome, the city that is the subject of the itinerary, and thus present on every page of the book. All the places outside of Rome are identified with the city where they are located.

Index of Names

The names listed below refer to the figures and the themes of the works cited in the texts, with the sole exception of Guido Reni, who is the subject of this tour and thus present on every page of the guidebook. As for the popes mentioned prior to being elected, their birth names are included.

Selected Bibliography

The titles listed here are essential and represent a small selection of the much more exhaustive and specialized contributions dedicated to Guido Reni. The texts suggested here are a starting point for anyone wishing to learn more about the works and Roman commissions of the great Bolognese master, as well as their importance to his success in both Italy and Europe. The list includes fundamental and canonical texts, as well as more recent studies and updates, thereby allowing the reader to focus on what they believe to be most interesting, and to create new itineraries inside and outside of Rome.

Sybille Ebert-Schifferer, *Guido Reni e l'Europa: fama e fortuna*, Frankfurt 1988

Andrea Emiliani, *Guido Reni*, Florence 1988

D. Stephen Pepper, *Guido Reni. A Complete Catalogue of His Works with an Introductory Text*, Oxford 1984

Elena Fumagalli, "Guido Reni (e altri) a San Gregorio al Celio e a San Sebastiano fuori le Mura," in *Paragone* 41 (1990), pp. 67–94

Judith W. Mann, "The Annunciation Chapel in the Quirinal Palace, Rome: Paul V, Guido Reni, and the Virgin Mary," in *The Art Bulletin* 75 (1993), pp. 113–134

Angela Negro, *Il giardino dipinto del Cardinal Borghese. Paolo Bril e Guido Reni nel Palazzo Rospigliosi Pallavicini a Roma*, Rome 1996

Daniele Benati, "Per Guido Reni 'Incamminato' tra i Carracci e Caravaggio," in *Nuovi Studi* 11 (2004–2005), pp. 231–247

Maria Cristina Terzaghi, *Caravaggio, Annibale Carracci, Guido Reni tra le ricevute del Banco Herrera & Costa*, Rome 2007

Raffaella Morselli, *Guido Reni da Bologna a Roma e ritorno*, in *Roma al tempo di Caravaggio*, catalogue of the exhibition curated by Rossella Vodret, 2 vols., Milan 2012, pp. 285–293

Pamela M. Jones, *Altarpieces and Their Viewers in the Churches of Rome from Caravaggio to Guido Reni*, London-New York 2016

Carlo Cesare Malvasia, *Felsina pittrice. Lives of the Bolognese Painters. Life of Guido Reni*, edited by Lorenzo Pericolo, 2 vols., London-Turnhout 20

Guido Reni and Rome. Nature and Devotion, edited by Francesca Cappelletti, catalogue of the exhibition, Rome March 1, 2022–May 22, 2022, Venice 2022.

Photo credits
© 2022. Foto Scala, Firenze;
© 2022. Foto Scala, Firenze. Si ringrazia l'Ufficio
Comunicazioni Sociali del Vicariato di Roma;
© 2022. Foto Scala, Firenze – su concessione Ministero
Beni e Attività Culturali e del Turismo;
© Accademia Nazionale di San Luca, Roma. Foto Mauro Coen;
© Internet Archive;
© Parigi, Louvre/RMN–Grand Palais/Hervé
Lewandowski/Dist. Foto SCALA, Firenze 2022;
© Roma - Sovrintendenza Capitolina ai Beni Culturali;
Archivi Alinari, Firenze;
Archivio fotografico dell'Archivio della Congregazione
dell'Oratorio di Roma, foto di Francesco Cantone;
Artokoloro/Alamy Photo Stock;
Bibliothèque nationale de France;
Bridgeman Images;
Bridgeman Images/Luisa Ricciarini;
Collection Groninger Museum, loan from Municipality of
Groningen, donation Hofstede de Groot, photo Marten
de Leeuw;
Foto © Governatorato SCV – Direzione dei Musei. Tutti i
diritti riservati;
Foto Istituto Nazionale di Archeologia e Storia dell'Arte, Roma;
Foto Mauro Coen;
Foto Mauro Coen. Si ringrazia la chiesa dei Santi Biagio
e Carlo ai Catinari, chiesa dei Padri Barnabiti a Roma;
Foto Mauro Coen. Si ringrazia l'Ufficio Comunicazioni
Sociali del Vicariato di Roma;
Gallerie Nazionali di Arte Antica, Roma (MiC) –
Bibliotheca Hertziana, Istituto Max Planck per la storia
dell'arte/Enrico Fontolan;
Immagine di proprietà della Principessa Maria Camilla
Pallavicini – foto Mauro Coen;
Londra, Collezione privata;
Michele Falzone/Alamy Stock Photo;
Mondadori Portfolio;
Mondadori Portfolio/Electa/Giuseppe Schiavinotto;
Nuova Arte Fotografica;
Roma-Sovrintendenza Capitolina-Museo di Roma;
Roma, Galleria Doria Pamphilj © 2022 Amministrazione
Doria Pamphilj s.r.l. Tutti i diritti riservati;
Segretariato Generale della Presidenza della
Repubblica, Roma – foto Mauro Coen;
Sergio Delle Vedove/Alamy Stock Photo;
Sovrintendenza Capitolina – Foto in Comune;
Courtesy of the Galleria Borghese, foto Mauro Coen;
Courtesy of the Ufficio Comunicazioni Sociali del
Vicariato di Roma, foto Mauro Coen.
The Metropolitan Museum of Art, Edward Pearce Casey
Fund, 1983;
The Metropolitan Museum of Art, The Elisha Whittelsey
Collection, The Elisha Whittelsey Fund, 1949.

Every reasonable effort has been made to acknowledge
the ownership or copyright for material included in
this volume. Any errors that may have occurred are
inadvertent and will be corrected in subsequent
editions, provided notification is sent to the publisher.

Reproduction
Opero S.r.l., Verona

Printing
L.E.G.O. S.p.A., Vicenza

for Marsilio Editori® s.p.a., Venezia
www.marsilioeditori.it